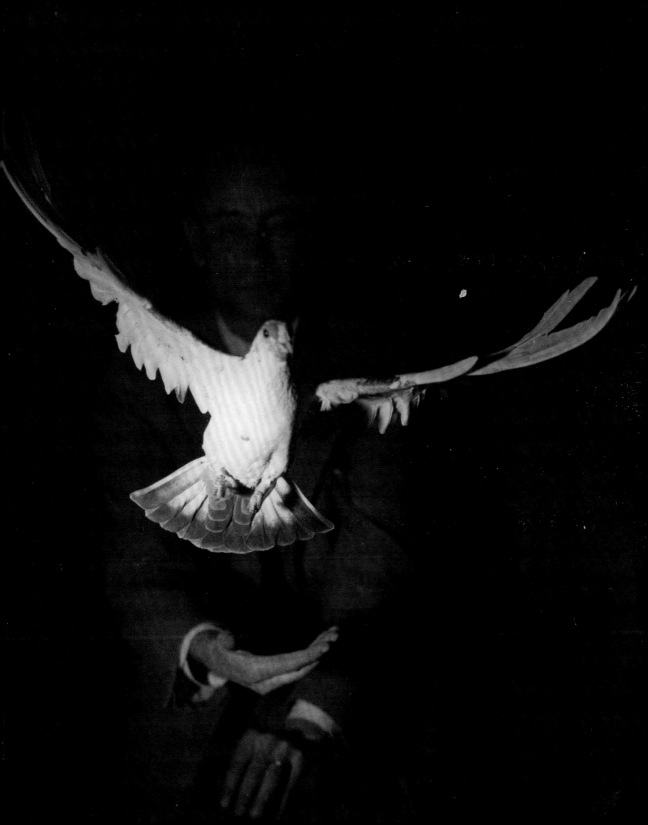

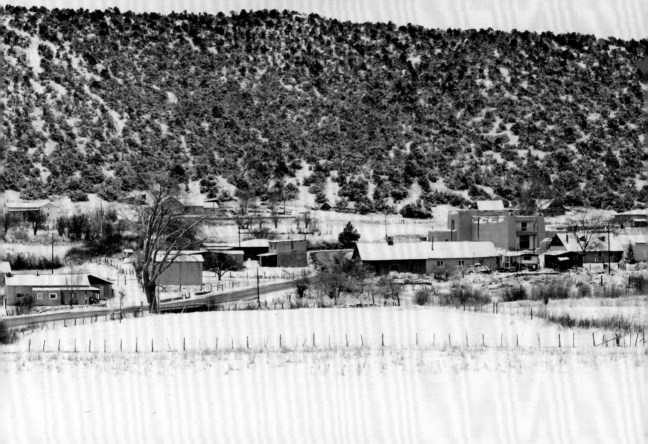
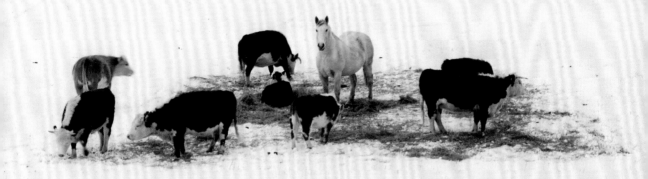

Animals

IN PHOTOGRAPHS

Arpad Kovacs

The J. Paul Getty Museum, Los Angeles

Sit, Stay, Pose:
Photographing Animals

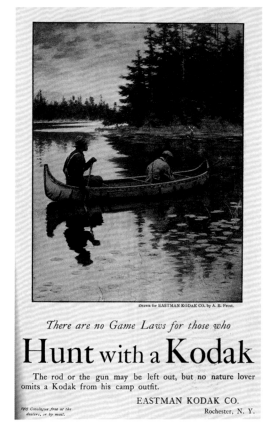

Drawn for EASTMAN KODAK CO. by A. B. Frost.

There are no Game Laws for those who

Hunt with a Kodak

The rod or the gun may be left out, but no nature lover
omits a Kodak from his camp outfit.

EASTMAN KODAK CO.

*1905 Catalogue free at the
dealers, or by mail.*

Rochester, N. Y.

*Zoos, realistic animal toys and the widespread
commercial diffusion of animal imagery, all began
as animals started to be withdrawn from daily life.
One could suppose that such innovations were
compensatory. Yet in reality the innovations them-
selves belonged to the same remorseless movement
as was dispersing the animals.[1]*

—John Berger

A 1905 illustrated advertisement for the Eastman Kodak
Company depicts two men in a canoe, one of whom is
aiming his camera at a deer carefully wading into the
shallow waters of a lake (fig. 1). The copy under the im-
age, drawn by the illustrator and graphic artist A. B. Frost,
announces, "There are no game laws for those who
hunt with a Kodak." This advertisement embodies two
notions that seemed to be of equal concern to Kodak and
its potential audience. First and foremost is the camera's
association with rifle hunting, an idea that has its roots
in Sir John Herschel's application of the shooting term
"snapshot" to photography in the 1860s.[2] The idea of
hunting with a camera gained a strong foothold among
amateur photographers, especially those who sought to
photograph animals in the wild, amid the introduction
of roll-film cameras in the late 1880s. Writing in 1900,

the American art critic James B. Carrington argued that
photographing animals in their natural habitats was even
more difficult than hunting with a gun. He explains: "To
get a picture of some shy animal or bird calls for all the
resources and knowledge of woodcraft that the best
of sportsmen may command, and pits the intelligence
of one against the other."[3] Along with conflating the
camera and the hunting rifle, the Kodak ad also calls
attention to the newly emergent nature-and-wildlife
conservancy movement. Its reference to hunting laws is
a nod to the Lacy Game and Wild Birds Preservation and
Disposition Act passed by the U.S. Congress in 1900, the
first national legislation for wildlife conservation.[4]

FIGURE 1. Eastman Kodak Company, Advertisement published in *Harper's*, 1905, Advertising Ephemera Collection, Emergence of Advertising On-Line
Project, John W. Hartman Center for Sales, Advertising & Marketing History, Duke University David M. Rubenstein Rare Book & Manuscript Library, K0523

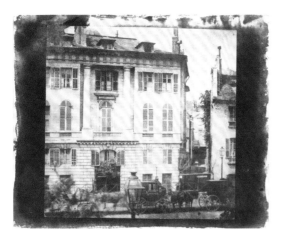

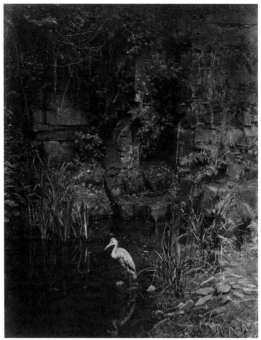

Companies like Kodak played a significant role in fueling and shaping popular conceptions of wildlife photography well before images of exotic animals began to appear on the glossy pages of *National Geographic* in the early years of the twentieth century. However, it was during the previous century that amateur and professional photographers alike initially exploited the aesthetic possibilities afforded by advancements in camera technology. Despite the limitations imposed by lengthy exposure times, successful photographic representations of animals were created in the early 1840s, not long after Louis-Jacques-Mandé Daguerre and William Henry Fox Talbot made their respective announcements of the invention of photography in 1839. During a visit to Paris in the spring of 1843, Talbot photographed a townhouse with a row of horse-drawn carriages waiting at street level (fig. 2). This salted paper print, taken from a window in a building across the street, captures the idling horses, including blurred sections where movement did not register on the negative. A few years later the Swiss nobleman and amateur photographer Jean-Gabriel Eynard focused the lens of his camera on a reclining white foal (plate 1). The subject is perfectly centered, and the half-plate daguerreotype reveals a considerable degree of visual detail that was likely achieved by Eynard's decision to photograph the animal at rest. These two early examples of photo-

graphic representation of animals demonstrate one of the fundamental limitations of the medium, which would persist for several decades and made animal photography particularly challenging: the difficulty of capturing a subject in motion. Similar to these images, most early photographs of animals can be divided into three categories: those whose subjects are captive, domesticated, or dead.

In 1857 *The Photographic Album*, the journal of the London-based Photographic Exchange Club, included an albumen print entitled *Piscator, No. 2* (fig. 3). Depicting a heron standing in a small pond surrounded by lush vegetation, the photograph was taken in June of the previous year by the British photographer John Dillwyn Llewelyn, a cousin of William Henry Fox Talbot.[5] By centering the bird in the picture frame, the photographer demarcated space and achieved visual balance, improving upon the natural setting that was presented before the camera lens. According to the accompanying caption, this image required

FIGURE 2. William Henry Fox Talbot (British, 1800–1877), *Boulevard des Italiens, Paris*, May 1843. Salted paper print from a calotype negative, 16.8 × 17.3 cm (6⅝ × 6¹³⁄₁₆ in.). Los Angeles, J. Paul Getty Museum, 84.XM.478.6

FIGURE 3. John Dillwyn Llewelyn (British, 1810–1887), *Piscator, No. 2*, 1856. Albumen silver print, 24.1 × 19 cm (9½ × 7½ in.). Los Angeles, J. Paul Getty Museum, 84.XA.871.5.20

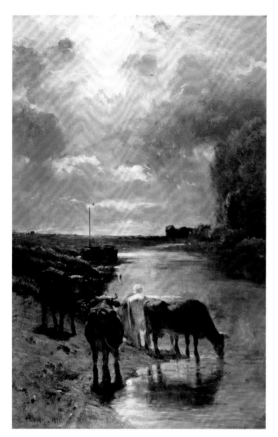

a twenty-minute-long exposure—a length of time that establishes that the bird was taxidermied, not a live animal.[6] Llewelyn's photograph is a staged scene that sought to emulate contemporary literary and painterly conventions for the realization of a harmonious composition.[7] Thus, rather than signaling a feat of technical accomplishment, the bird's presence offers insights into the relationship between early practitioners of the medium and academic pictorial traditions of the period, particularly those deployed in the realm of landscape painting.

The popularity of zoological subject matter during the mid-nineteenth century was largely due to the work of the French Barbizon painters and their contemporaries in The Hague School. Artists in both movements incorporated motifs of working animals into their paintings, in the process reviving the genre of animal art that had flourished in the seventeenth century in the hands (and brushes) of Dutch and Flemish painters such as Roelant Savery and Frans Snyders. Paintings of animals by members of the Barbizon School, including Constant Troyon (fig. 4) and Philippe Rousseau, were prominently featured at the French Salon during the mid-nineteenth century, and their work suggested a need for reference photographs for artists who did not have access to livestock.[8] This need was met by photographers such as Édouard Baldus, Léon Crémière (plate 17), Louis-Jean Delton, Camille Silvy, and Adrien Tournachon, who marketed their animal photographs to painters as technical aids.[9]

FIGURE 4. Constant Troyon (French, 1810–1865), *Cattle Drinking*, 1851. Oil on oak panel, 78.4 × 51.8 cm (30⅞ × 20⅜ in.). Baltimore, MD, Walters Art Museum, 37.59

FIGURE 5. Frank Haes (British, 1832–1916), *The South African Cheetah (Felis Jubata)*, ca. 1865. Albumen silver print, 8 × 17.7 cm (3³⁄₁₆ × 7 in.). Los Angeles, J. Paul Getty Museum, 84.XC.873.5354

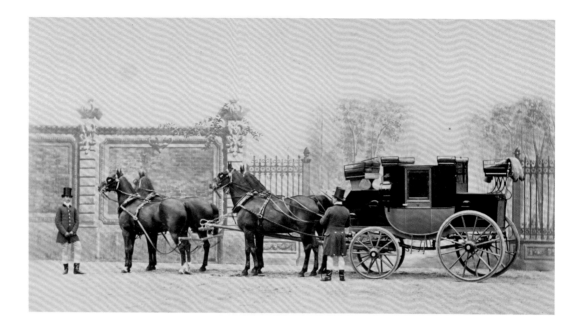

Photographers with ready access to farm animals took pictures of cows, bulls, and sheep, while others documented horses, hunting dogs, and, increasingly, wild and exotic animals housed in aviaries and public zoological gardens (fig. 5). The genre of equestrian photography, featuring horses positioned against elaborately painted backdrops, was made popular by Delton and Tournachon, among others, both of whom produced albums for well-heeled customers (fig. 6). Tournachon, whose brother Félix (better known by his pseudonym, Nadar) was a highly successful photographer in Paris, focused his camera on racehorses (plate 11). Crémière frequently photographed livestock, but also became renowned for his posed photographs of hunters with their hounds, along with dynamic groupings of dogs who seem to be patiently awaiting the hunt (plate 17).

The French photographer André-Adolphe-Eugène Disdéri's introduction of the multiple-lens carte-de-visite camera in 1854 helped to popularize portrait photographs among the middle and upper classes.[10]

The carte-de-visite camera permitted small sections of a single glass negative to be exposed at different times, enabling the printing of multiple images on one sheet of paper; these small prints, mounted on board (essentially the same size as calling cards), were collected in vast numbers, and often exchanged among friends and acquaintances. Studios equipped with props and elaborate backdrops opened in large cities across Europe to fill the growing demand for portrait photography, a genre in which animals would play an important role. Some studios provided stuffed dogs and horses to pose with clients, and, later, studios began to photograph people with their pets (plates 8, 9).[11] These intimate images presented animals as social markers and family members, but other types of animal imagery also thrived during the middle of the nineteenth century.

The revival of animal subject matter in painting served to enhance the popularity of another type of animal photography: that realized within the context of still life. In the mid-nineteenth century, painters began

FIGURE 6. Louis-Jean Delton (French, before 1820–after 1899), *Mail Coach du Cte. Ed. de Lambertye*, 1865. From the album *Hippique*. Albumen silver print, 15 × 27.5 cm (5¹⁵⁄₁₆ × 10¹³⁄₁₆ in.). Los Angeles, J. Paul Getty Museum, 84.XO.823.5.6

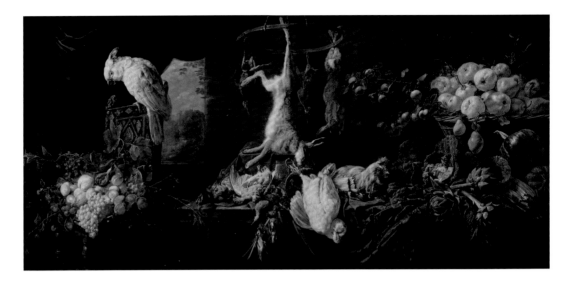

revisiting the work of masters of the genre, including that of the seventeenth-century Flemish painter Adriaen van Utrecht (fig. 7) and the eighteenth-century French painter Jean-Siméon Chardin (fig. 8). The French commercial photographer Adolphe Braun (plate 14) started photographing animals around 1860, after acquiring a farm in the Swiss village of Dornach that provided him with specimens of various working animals.[12] Along with photographing livestock, he staged still-life scenes with game and floral arrangements. Braun initially entered the field of animal photography as a means of producing accurate points of reference for those who wished to incorporate animal motifs into their canvases but who were not able to observe these subjects directly from nature. He quickly shifted from making merely useful images, however, to "creating products that arranged subjects from nature in deliberately artistic ways."[13] Braun's staged compositions—often featuring wild hares, pheasants, and boar— were modeled on prototypes popularized by successful painters of the genre. Published in Disdéri's *L'Art de la photographie* and Léopold Mayer and Louis Pierson's *La Photographie considerée comme art et comme industrie* (both 1862), these photographs, often quite large in

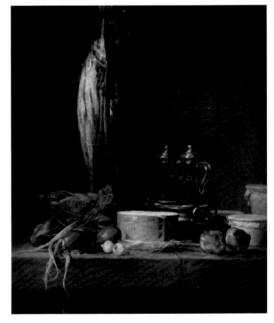

FIGURE 7. Adriaen van Utrecht (Flemish, 1599–1652), *Still Life with Game, Vegetables, Fruit, and a Cockatoo*, 1650. Oil on canvas, 120 × 250.5 cm (47¼ × 98⅝ in.). Los Angeles, J. Paul Getty Museum, 69.PA.13

FIGURE 8. Jean-Siméon Chardin (French, 1699–1779), *Still Life with Fish, Vegetables, Gougères, Pots, and Cruets on a Table*, 1769. Oil on canvas, 68.6 × 58.4 cm (27 × 23 in.). Los Angeles, J. Paul Getty Museum, 2003.13

scale (see plate 14), were no longer intended to serve as visual aids but as artworks in their own right, designed to compete with decorative lithographs of more expensive paintings.

The earliest attempts to photograph animals in their natural habitats can be traced to two separate expeditions to the African continent.[14] The first, undertaken in 1858, was an exploratory mission to the Zambezi River and its tributaries, organized by the Scottish missionary David Livingstone.[15] Accompanying the group was the explorer James Chapman, who packed two cameras with the intention of photographing zebras, wildebeests, and elephants, among other exotic creatures. The second expedition occurred five years later, when the German explorer Gustav Fritsch journeyed to South Africa, equipped with a camera and plates.[16] In both cases, the difficulties of working with wet-collodion materials in the field, combined with unpredictable weather and unwilling subjects, resulted in the failure to produce a single photograph of a live animal. During the second expedition, the only animal photographs made were of game that had first been shot and killed by Fritsch's companions.[17] Shooting to kill one's animal subject was a well-established practice among photographers and other artists, as the alternative, using taxidermied specimens, often produced less than satisfying results (plate 22). The French-American ornithologist and illustrator John James Audubon, who executed meticulously rendered drawings and watercolors of birds, famously remarked, "I shot, I drew, I looked upon nature."[18]

Perhaps the first successful photograph of a living wild animal in the field is that of a stork on its nest, taken by the Boston-based Charles A. Hewins in 1870 while traveling in Strassburg, Austria.[19] Six years later the goal of photographing animals in their natural habitats was finally realized, as the result of the HMS *Challenger* expedition to Antarctica (1872–76), made up of both scientists and photographers. Organized by the Royal Society of London and complete with darkroom equipment on board, the *Challenger* expedition returned with photographs of penguin rookeries and even breeding albatrosses.[20]

By the early 1870s animals began to play a prominant role in the technical development of photography. Several photographers in the United States and Europe deployed animal subjects in their investigations into the possibilities of recording movement. In his 1873 essay "On Photographing Horses," published in the *British Journal Photographic Almanac*, the London-based photographer Oscar Gustave Rejlander "proposed using a battery of cameras and 'quick-acting lenses' ready charged and loaded" to create a sequence of images depicting motion.[21] The following year Étienne-Jules Marey's *La machine animale: Locomotion terrestre et aérienne*, detailing locomotion's central role in the science of movement, appeared in English translation as *Animal Mechanism*. In this text Marey theorized that there were moments when, during a horse's gallop, all four of the animal's hooves were off the ground, contributing to the animal's speed.

Among those convinced by Marey's theory was the American industrialist, politician, and avid horseman Leland Stanford. Seeking visual proof, Stanford commissioned the photographer Eadweard Muybridge to photograph his prized thoroughbred, Occident. Utilizing Marey's largely untested methods and equipped with considerable sums of capital provided by Stanford, Muybridge devised a system for simultaneously tripping the shutters of twelve cameras arranged on a low shelf twenty-one inches apart as the horse moved across a racetrack.[22] The shutters were mechanized by means of an electromagnetic release, for which Muybridge applied for a patent on June 17, 1878, describing it as a "method and apparatus for photographing objects in motion."[23] Muybridge's invention succeeded in visually halting the motion of a rapidly moving horse (fig. 9), something that the human eye is unable to do, and demonstrated Marey's theory to be correct. Muybridge continued to refine this technique to photograph the movements of other animals and people engaging in various activities. In addition to Marey in Paris, other photographers, such as Ottomar Anschütz in Berlin, likewise sought to refine this method of producing photographic studies of motion, known as "chronophotography."

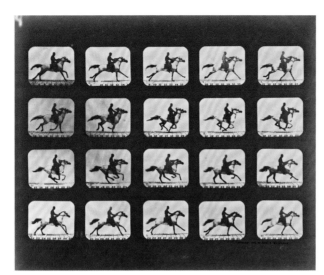

By the end of the nineteenth century, as Eastman Kodak's advertisements began to explore the notion of hunting with the camera, hobbyists and self-proclaimed professionals endeavored to create more dynamic photographs of animals. Technological advancements in the medium gave rise to smaller cameras, lenses capable of sharper focus, and faster film than was previously available. These innovations gradually enabled greater flexibility and began to shape the way animals were photographed, especially with regard to notoriously difficult avian subjects. The English photographer brothers Richard and Cherry Kearton started photographing birds in the early 1890s, publishing their first book, *British Birds' Nests: How, Where, and When to Find and Identify Them*, in 1895. The Keartons pioneered unusual techniques for getting close to their subjects without scaring them away, and were among the first to successfully photograph birds in their natural habitats (fig. 10). The brothers became famous for the acrobatic feats they performed to obtain photographs of birds, including rappelling down cliff faces and climbing to the tops of trees.[24] Their work contributed to the emerging field of wildlife photography, a genre that by the early twentieth century would help fuel the emergence

and popularity of illustrated scientific publications issued by England's Royal Geographic Society and its American counterpart, the National Geographic Society. These publications joined written narratives influenced by literary genres such as the travelogue, with photographs of unfamiliar subjects in exotic locales. This combination served a primarily pedagogical function. As these types of publications developed and their audiences became accustomed to seeing close-ups of wild animals, a sense of intimacy developed between viewer and subject, further contributing to the rising interest in such imagery.

In the early years of the twentieth century, the wildlife conservation movement in the United States gained traction in the public consciousness, as well as among state and federal governments. The roots of the movement may be traced back several decades earlier—specifically to March 1, 1872, the date Congress passed the Yellowstone Act, establishing Yellowstone National Park in the territories of Montana and Wyoming "as a public park or pleasuring-ground for the benefit and enjoyment of the people."[25] The creation of a federally mandated public park coincided with the ongoing slaughter of bison herds across much of the American West. The demand

FIGURE 9. Eadweard J. Muybridge (American, born England, 1830–1904), *One Print*, 1878–81, from the album *The Attitudes of Animals in Motion*. Iron salt process print, 19 × 22.5 cm (7½ × 8⅞ in.). Los Angeles, J. Paul Getty Museum, 85.XO.362.43

FIGURE 10. Cherry Kearton (British, 1871/73–1940), *Kittiwakes at Home*, negative, 1896; print, 1905. Hand-colored photogravure print, 23 × 19.5 cm (9¹⁄₁₆ × 7¹¹⁄₁₆ in.). Los Angeles, J. Paul Getty Museum, 84.XM.500.1

for bison hides, their carcasses often left to rot, intensified with the westward expansion of the following decades, such that by 1886 a federal census reported the existence of only 540 bison in the United States, most of which were to be found in Montana's Yellowstone region.[26] In 1880 the photographer Laton Alton Huffman established a studio at a military post in eastern Montana, with much of his business centering on portraits of white settlers and First Nations people. He also produced many photographs of bison herds traveling across the expansive landscape, along with images of recently killed animals (plate 25).

While Huffman and many of his contemporaries saw their role as one of documenting the environmental changes that swept the American West, tragically embodied by the decimation of the nation's bison population, art photographers embraced an aesthetic that aimed to move beyond the simple transcription of nature in favor of greater personal and emotional expression. This development gathered strength amid the international Pictorialist movement of the late nineteenth century. Practitioners of Pictorialism emphasized a soft and selective focus, which distinguished their photographs from what they saw as the cold and distracting precision of commercial photography. Techniques such as the manipulation of both the negative and the print, the application of developer with a brush to mimic watercolor strokes, and the use of papers with textured surfaces together resulted in prints that could be appreciated as unique art objects. Pictorialist photographers made use of animal subjects as props and occasionally as signifiers of abstract ideas explored by painters, such as "the pastoral," "domesticity," or "fidelity." Photographs of farm animals presented the noble pursuit of rural life and traditional occupations as expressions of nostalgia, while pets were often cast as the embodiment of the realms of family and leisure, exemplified in pictures taken by artists such as Clarence H. White (plate 27) and Arnold Genthe (plate 28).

By the end of the first decade of the twentieth century, Pictorialism's core tenets were succeeded by new approaches. The American photographer, gallerist, and publisher Alfred Stieglitz, initially a leading promoter of Pictorialist photography as an art form on a par with painting, largely abandoned the movement by 1910. As founder of the 291 gallery, Stieglitz exhibited the European avant-garde, including works by Henri Matisse and Pablo Picasso, among others, and praised Picasso's Cubist work for being "anti-photographic" in its rejection of the vanishing-point perspective imposed by the camera.[27] He began to advocate for an art photography that likewise renounced the perspective present in existing photographic traditions and instead aspired to greater personal and spiritual expression. In Stieglitz's work, as well as that of his like-minded contemporaries, the Pictorialist emphasis on selective and soft focus ultimately gave way to crisp photographs that reexamined familiar subjects in radically new ways. Taken in 1923, Stieglitz's photograph *Spiritual America* (plate 29) is perhaps one of the most iconic indicators of this shift. This image of a harnessed and castrated horse is a commentary on American identity, which Stieglitz viewed as materialist and culturally bankrupt. The subject's restrained muscular energy, along with the eradication of its sexual prowess, suggested that America was lacking in spirit. By reducing a horse, the leading American symbol of unstoppable force, to a slick display of geometry, *Spiritual America* represents the triumph of metaphor in American photography.[28]

In Germany, the Bauhaus, the groundbreaking institution founded in 1919 to educate students in architecture, craft, and the fine arts, gave rise to the photographic style known as the New Vision. With an emphasis on close-ups, unusual angles, and repeated visual patterns, New Vision photographers refocused their cameras equally on the quotidian and the exotic, including animals, to highlight the inherent beauty of the subject. Photographers outside of the Bauhaus also worked in the New Vision style. The extreme close-up of the subject's face in Albert Renger-Patzsch's *Sacred Baboon* mimics the qualities of a formal portrait, redefining the notion that animals can only be objects of study or props (plate 35). The critic Donald Kuspit writes, "Renger-Patzsch emphasizes the details of things almost to the point where they disrupt the representation."[29] By focusing on a closely cropped detail of the animal, the baboon's face, Renger-Patzsch's celebrated photograph makes visible an aspect

of the subject so obvious as to otherwise be overlooked: its close relationship to the human face.

Amid the rise of industry in the aftermath of World War I, the general public began to encounter photographs in unprecedented numbers through photomechanical reproductions in newspapers and magazines. Photojournalism became a source of income for many art photographers in postwar Europe, prompting figures such as André Kertész and Martin Munkácsi to relocate to vibrant urban capitals like Paris and Berlin to photograph for popular publications, including *Vu* and *Berliner illustrirte Zeitung*. Many of these photographers retained an interest in producing less commercial and more experimental work that explored the potential of basic visual principles of form, volume, and contrast (plate 30). The importance of the printed media in circulating new and unusual types of imagery continued up until and following World War II, with many photographers moving to the United States to work for commercial publications.

In the 1960s, while working for the fashion magazine *Harper's Bazaar*, the Chinese-born Japanese American photographer Hiro created a series of photographs of various animals posed with jewelry produced by the likes of Van Cleef & Arpels and David Webb. The unusual image of a dead fish modeling a diamond necklace reveals chromatic similarities between the animal's scales and the fashion accessory (plate 51). Hiro's photograph of a small owl examining a jeweled replica of a toad that it has steadied with one of its talons is whimsical in its representation of a predator and its "prey" (plate 52).

The use of humor became a core strategy of the Conceptual Art movement, as seen in the work of William Wegman, who used photography to document the constructed tableaux and changeable sculptures he created in his studio. Since the early 1970s Wegman has primarily been known as a photographer of Weimaraner dogs posed in comical, strange, and endearing ways. In 1970 he purchased his first Weimaraner, whom he named Man Ray, after the famous Surrealist photographer. The dog quickly began making appearances in his photographs and videos, variously serving as a prop, a collaborator, a stand-in for the artist, or a subject that performed simple choreographed tasks, like moving its head to follow a ball located outside the camera's frame (plate 55). Wegman has described his decision to include Man Ray in his work as largely due to the dog's physical attributes: "I just loved the way he looked. This neutral gray, it was almost like a charcoal drawing."[30] The dog was also a willing participant, as Wegman shared in an interview: "He had an intense way of telling me that he wanted to be included. I remember on several occasions trying to work with other things to keep him out of it, and he'd keep dumping stuff over onto the set."[31]

Animals continue to fascinate contemporary artists and photographers. Taryn Simon utilizes photographs to document in-depth research projects that reveal the complex networks underlying public and private enterprises, along with government entities. For her 2007 series An American Index of the Hidden and Unfamiliar, she created photographs at sites across the United States that are generally inaccessible to the public. They included a wildlife refuge facility in Arkansas, where Simon photographed a malformed tiger with significant health problems caused by an inbreeding practice that seeks to produce "perfect" white tigers (plate 78). The ethics surrounding the questionable treatment of animals are also explored in the work of the South African photographer Pieter Hugo. For his series the Hyena and Other Men, Hugo photographed members of a group called "Hyena Men," who live on the periphery of Lagos, Nigeria, performing in the streets with large, elaborately restrained wild animals in front of local crowds (plate 79). While firmly gripping the leash, these men dance with the animals and demonstrate a seemingly innate ability to dominate and tame wild creatures. This traveling troupe is a family business in which the tradition of specific movements and interactions with animals is passed down through generations. Hugo's unsettling images also trace complex relationships in which notions of the domestic and the wild, dominance and submission, are constantly in flux.

The concept of the wild is likewise examined in the work of another South African photographer, Daniel Naudé, who has created intimate portraits of Africanis

dogs. On a trip from Cape Town to Mozambique, Naudé discovered packs of wild dogs on the plains of the Karoo, a geographical expanse with an arid climate. This encounter led to numerous return trips to track, follow, and photograph these feral dogs, whose origins date to ancient Egypt. Naudé slowly developed a bond with a number of the animals, allowing him to photograph them in close proximity. Many of the photographs in the series adhere to a similar format, in which individual subjects are posed in the center of the frame and captured from a low vantage point, with a broad view of the desert landscape in the background. These images are reminiscent of equestrian portraiture of the seventeenth century, elevating the unkempt wild dogs to a state majesty (figs. 11, 12).

Over the course of the medium's rich but relatively short history, animal photographs have taken on a multiplicity of meanings and performed a wide array of roles, including serving as both supplements to and illustrations of scientific studies; as records of environmental changes, with highly affective undertones; as beautifully staged advertisements for goods and services;

and as sources of delight and merriment. It is perhaps the ubiquity of animal imagery that prompted the critic John Berger to pose a deceptively simple query as the title of his 1977 essay "Why Look at Animals?" His question provides a springboard to a larger critique of late capitalist society, which, for Berger, has systematically excised most animals from the daily lives of human beings and replaced them with intermediaries such as photographic and cinematic representations. This change signals a shift in our knowledge and understanding of animals, and, most importantly, has erased the possibility of the animal returning our gaze. With evident sadness, Berger observes, "that look between animal and man, which may have played a crucial role in the development of human society, and with which, in any case, all men had always lived until less than a century ago, has been extinguished."[32]

FIGURE 11. Paulus Potter (Dutch, 1625–1654), *The "Piebald" Horse*, ca. 1650–54. Oil on canvas, 50.2 × 45.1 cm (19¾ × 17¾ in.). Los Angeles, J. Paul Getty Museum, 88.PA.87

FIGURE 12. Daniel Naudé (South African, b. 1984), *Africanis 17. Danielskuil, Northern Cape, 25 February 2010*, 2010. Chromogenic print, 73.7 × 73.7 cm (29 × 29 in.). Los Angeles, J. Paul Getty Museum, 2014.26.1

NOTES

1 John Berger, "Why Look at Animals?," in *About Looking* (New York: Pantheon, 1980), 26.

2 Brian Coe and Paul Gates, *The Snapshot Photograph: The Rise of Popular Photography, 1888–1939* (London: Ash & Grant, 1977), 6.

3 Matthew Brower, *Developing Animals* (Minneapolis: University of Minnesota Press, 2011), 25.

4 Robert D. Brown, "The History of Wildlife Conservation and Research in the United States: With Implications for the Future," in *Proceedings of the Taiwan Wildlife Association*, edited by H. Li (Taipei, 2007), 9, http://cnr.ncsu.edu/fer/directory/documents/Article-HistoryofWildlifeResearch.pdf, accessed April 26, 2014.

5 Brower begins the first chapter of *Developing Animals* with an extensive account of Llewelyn's *Piscator, No. 2.*

6 Brower, *Developing Animals*, 6.

7 Charles Mallard, "Image of Nature," in *Nature and the Victorian Imagination,* edited by U. C. Knoepflmacher (Los Angeles: University of California Press, 1977), 25.

8 Maureen O'Brien, "The Influence of French Painting," in *Image and Enterprise: The Photographs of Adolphe Braun,* edited by Maureen O'Brien and Mary Bergstein (London: Thames & Hudson, 2000), 77.

9 Ibid.

10 Anne McCauley, *A. A. E. Disdèri and the Carte de Visite Portrait Photograph* (New Haven: Yale University Press, 1985).

11 Margaret Harker, "Nineteenth-Century Animal Photography," in *The Animal in Photography, 1843–1985*, edited by Alexandra Noble (London: Photographers' Gallery, 1986), 24–35.

12 O'Brien, "The Influence of French Painting," 77.

13 Ibid.

14 Derek Bouse, *Wildlife Films* (Philadelphia: University of Pennsylvania, 2000), 40.

15 C. A. W. Guggisberg, *Early Wildlife Photographers* (New York: Taplinger, 1977), 12.

16 Guggisberg, *Early Wildlife Photographers*, 13.

17 Ibid.

18 Bouse, *Wildlife Films*, 40.

19 Guggisberg, *Early Wildlife Photographers*, 14.

20 Guggisberg, *Early Wildlife Photographers*, 14–15.

21 Philip Brookman, "Helios: Eadweard Muybridge in a Time of Change," in *Helios: Eadweard Muybridge in a Time of Change*, edited by Philip Brookman (London: Tate, 2011), 78.

22 Brookman, "Helios," 81.

23 Brookman, "Helios," 82.

24 Brower, *Developing Animals*, 100.

25 National Park Service, http://www.nps.gov/aboutus/history.htm, accessed April 26, 2014.

26 Brown, "The History of Wildlife Conservation and Research in the United States," 4.

27 Mary Warner Marien, *Photography: A Cultural History* (London: Laurence King, 2006), 181.

28 Allan Sekula, "On the Invention of Photographic Meaning," *Artforum* 13 (January 1975): 37–45.

29 Donald Kuspit, "Albert Renger-Patzsch: A Critical-Biographical Profile," in *Albert Renger-Patzsch: Joy before the Object* (New York: Aperture, 1993), 68.

30 Michael Gross, "Pup Art," *New York Magazine* 25, no. 13 (March 30, 1992): 46–47.

31 Ibid.

32 Berger, "Why Look at Animals?," 28.

Plates

From the collection of the J. Paul Getty Museum

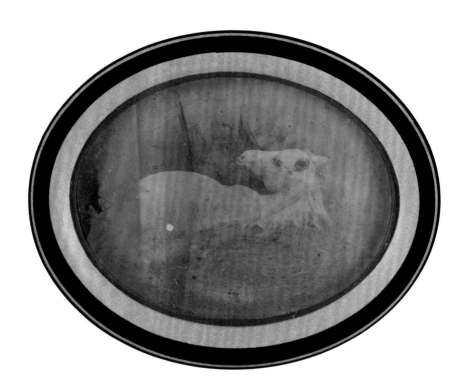

1 JEAN-GABRIEL EYNARD
Study of a White Foal, ca. 1845

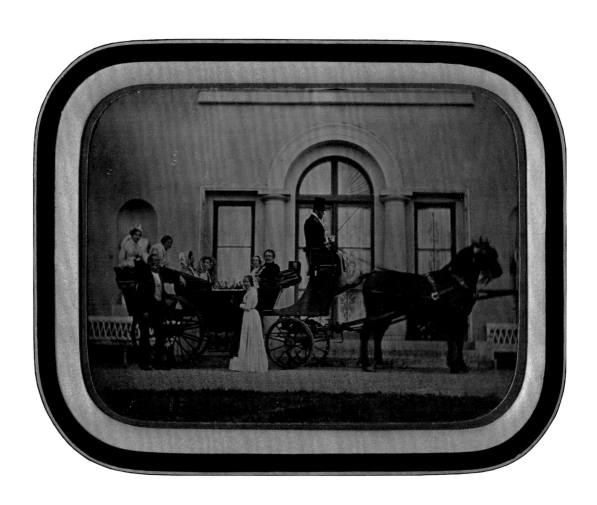

2 JEAN-GABRIEL EYNARD
Carriage with Figures, 1849

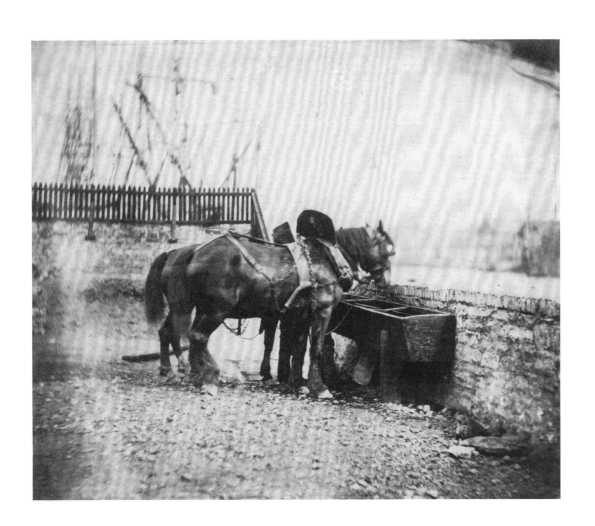

4 JOHN BEVAN HAZARD
Horses at a Trough, 1850s

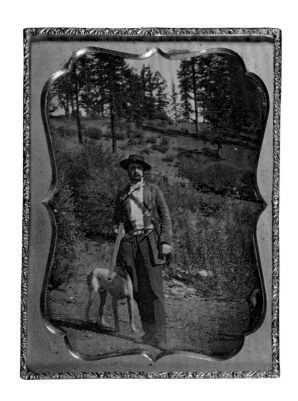

5 UNKNOWN AMERICAN DAGUERREOTYPIST
Outdoor Scene with Hunter and Dog, ca. 1850

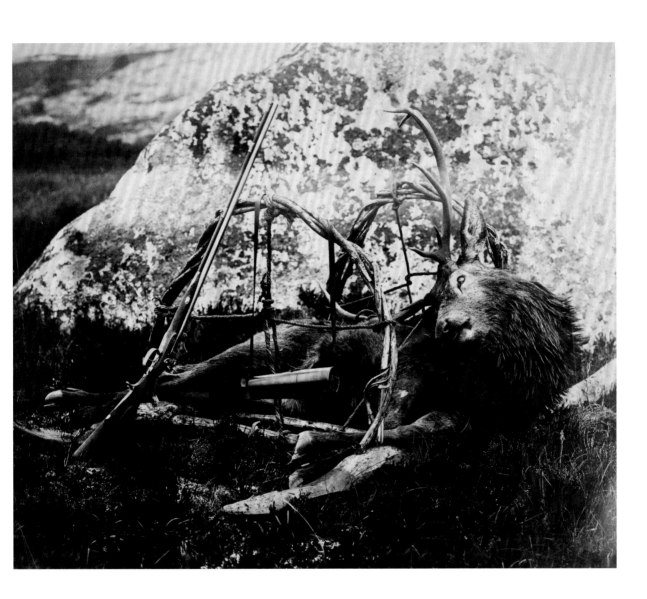

6 HORATIO ROSS
Dead Stag in a Sling, 1850s–60s

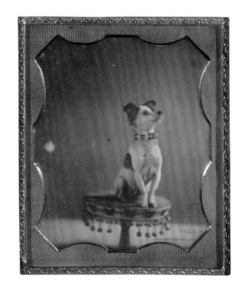

UNKNOWN AMERICAN DAGUERREOTYPIST
Dog Sitting on a Table, ca. 1854

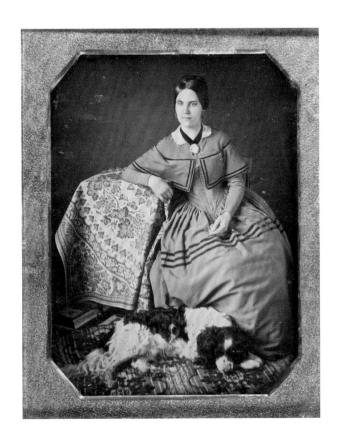

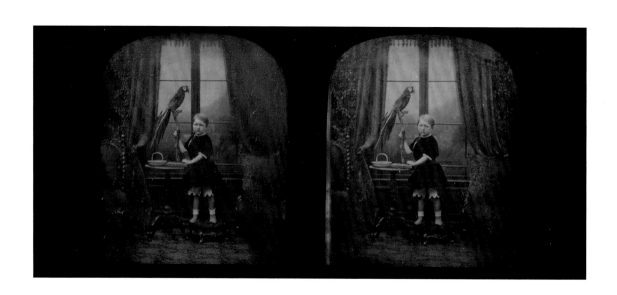

9 ANTOINE CLAUDET
Boy with Parrot, ca. 1856

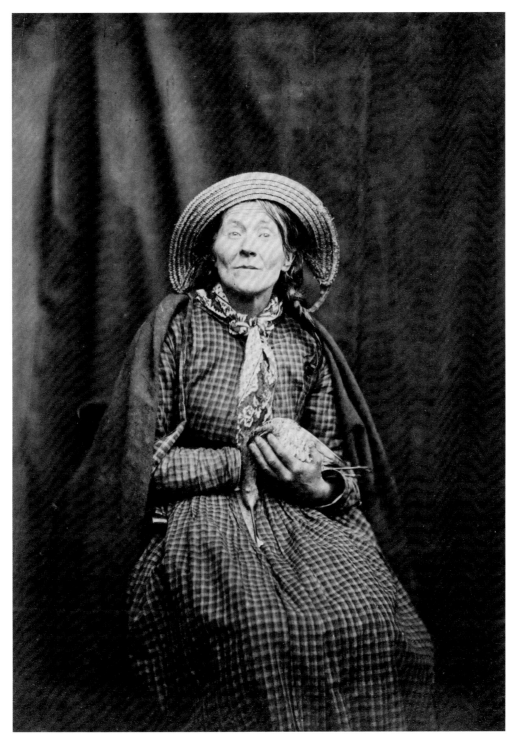

10 HUGH WELCH DIAMOND
Seated Woman with a Bird, ca. 1855

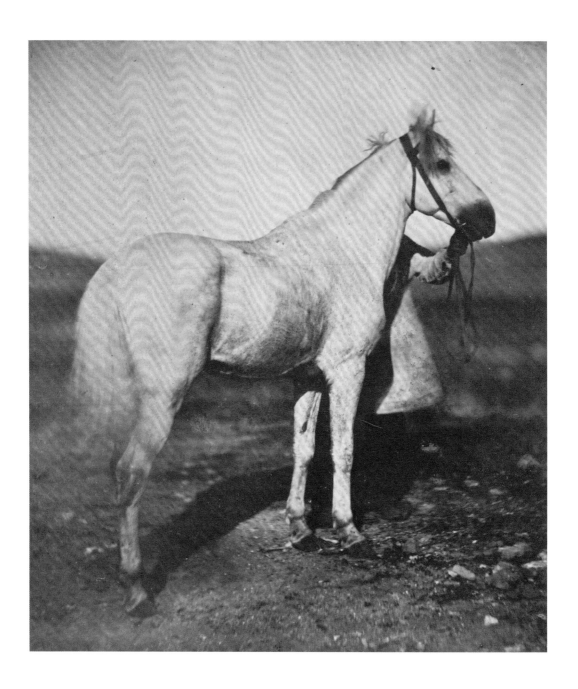

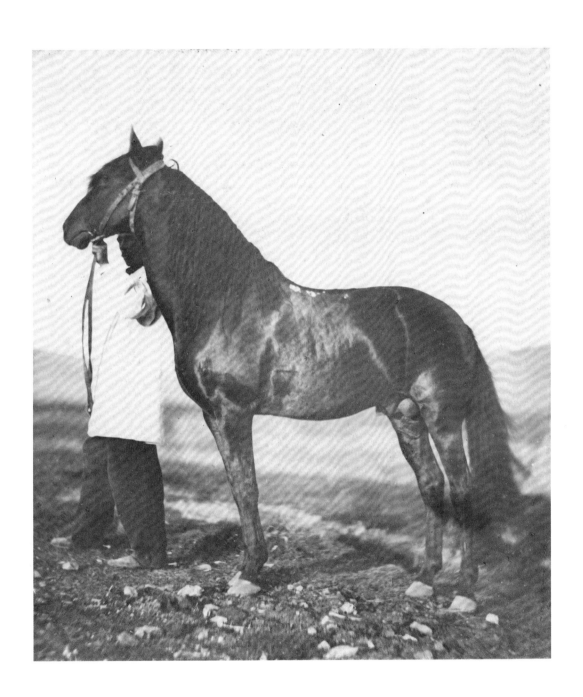

11 ADRIEN ALBAN TOURNACHON
Two Horses with Their Handlers, 1856

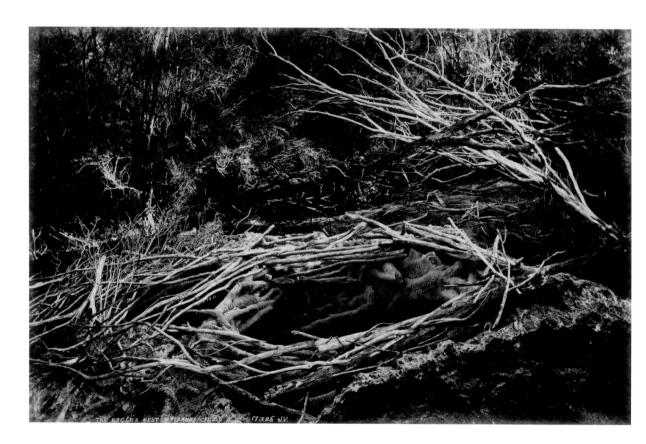

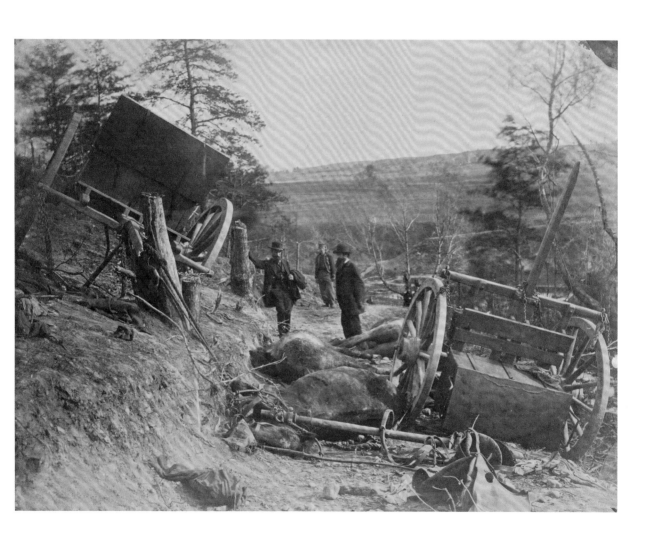

13 ANDREW JOSEPH RUSSELL
Scene of Battle, Fredericksburg, Virginia, May 3, 1863

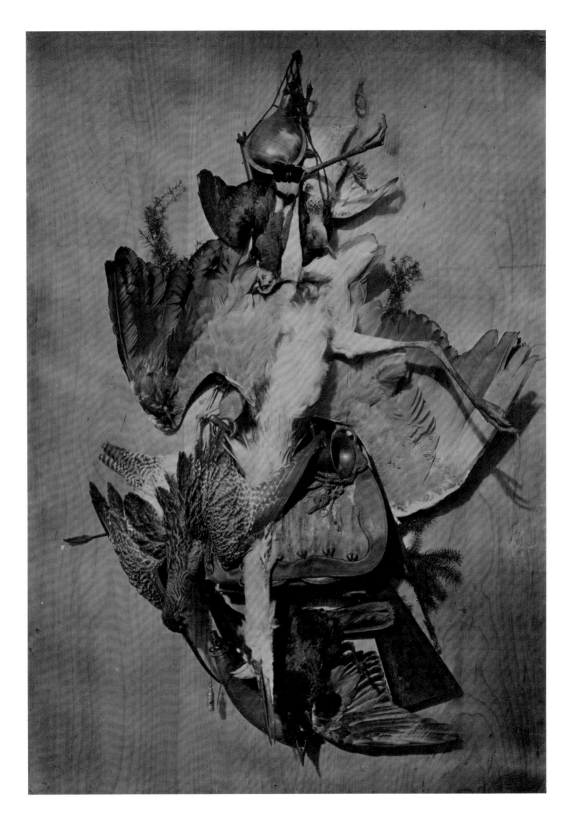

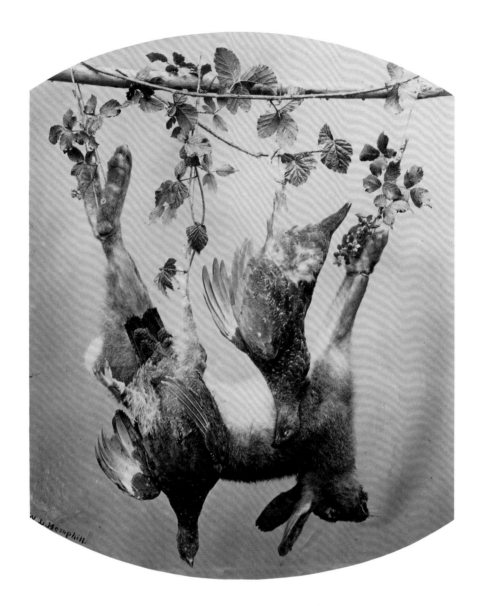

14 ADOLPHE BRAUN
Still Life of Game, 1865

15 WILLIAM DESPARD HEMPHILL
Still Life with Dead Animals, 1860s–70s

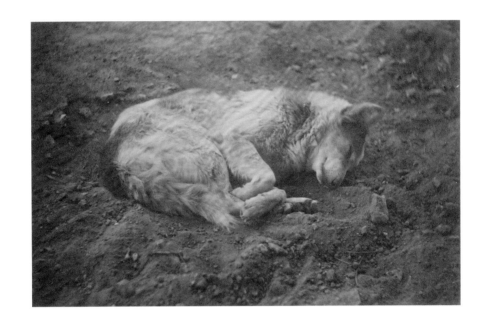

THÉODULE DEVÉRIA
Sleeping Dog, 1865

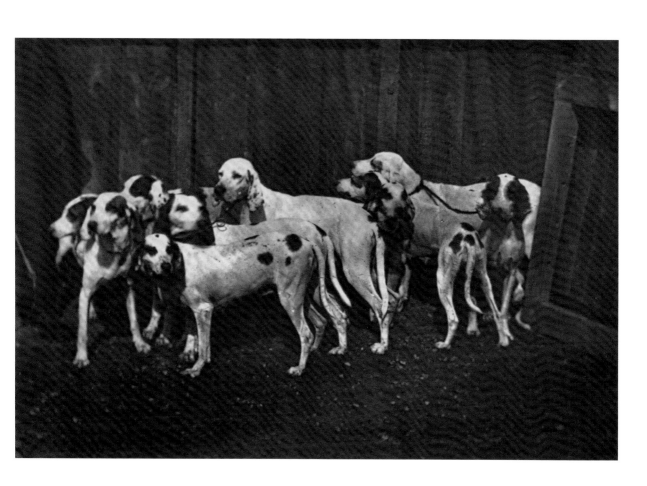

17 LÉON CRÉMIÈRE
Dogs, mid- to late 19th century

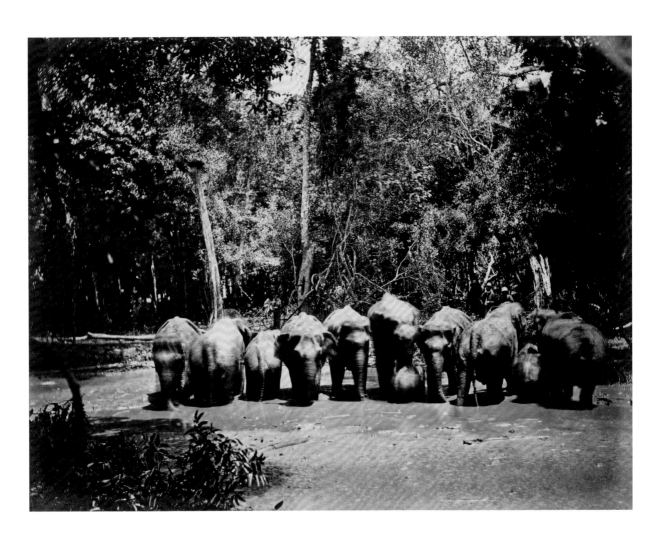

18 ERNEST LAWTON
Heads and Tails, ca. 1866

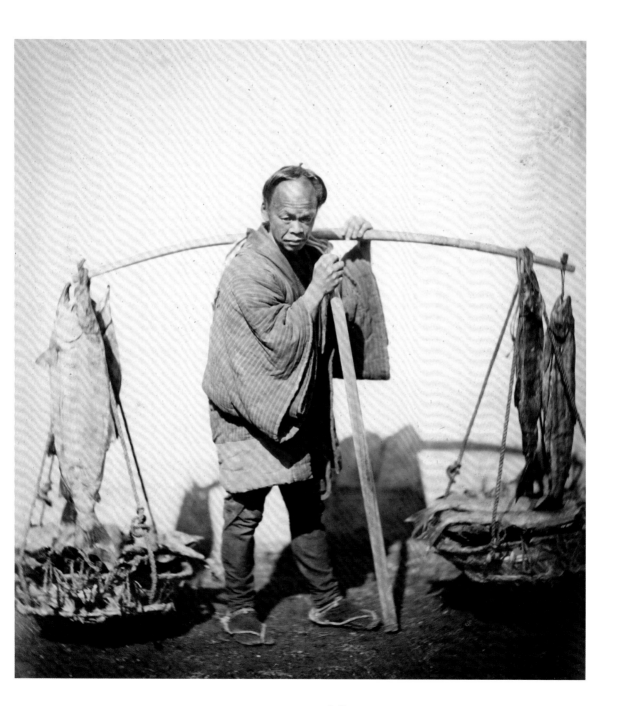

19 FELICE BEATO
Fishmonger, 1866–67

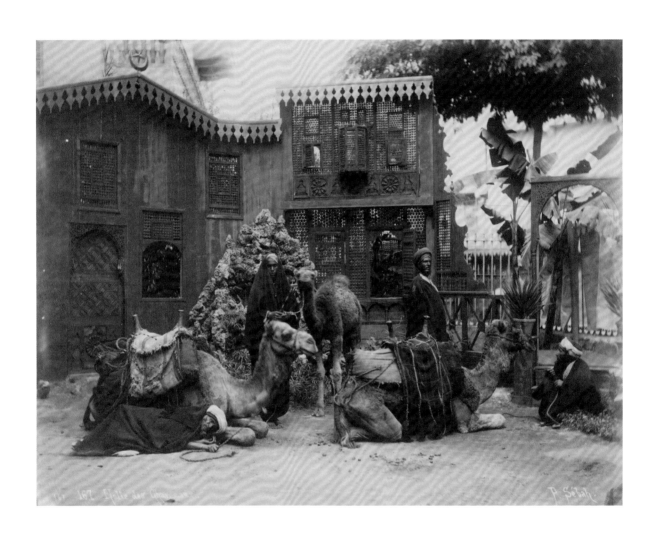

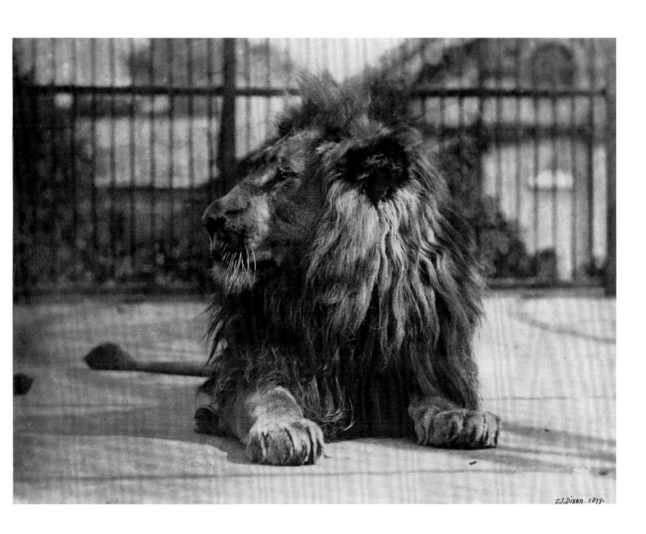

21 THOMAS JAMES DIXON
Lion at Zoo, 1879

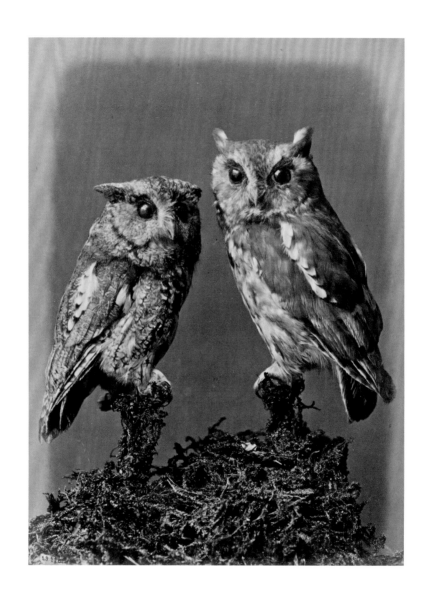

22 WILLIAM NOTMAN
Screech Owl, Mottled Owl. Red & Gray Stages, 1876

EADWEARD J. MUYBRIDGE
Animal Locomotion, 1887

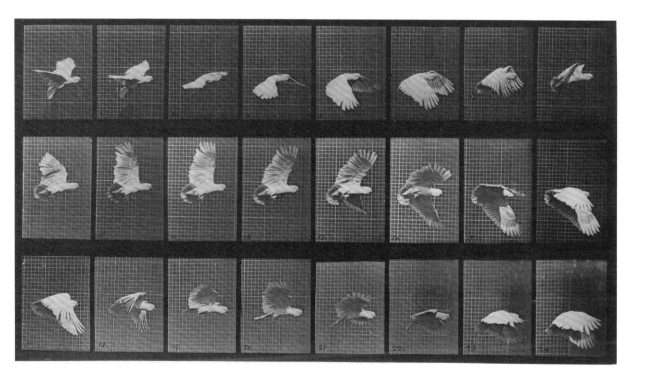

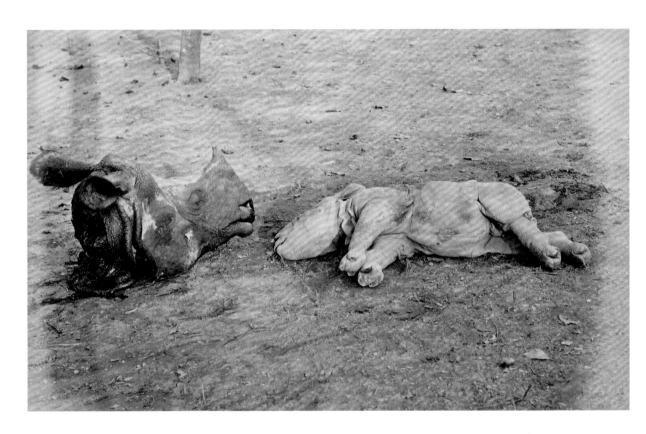

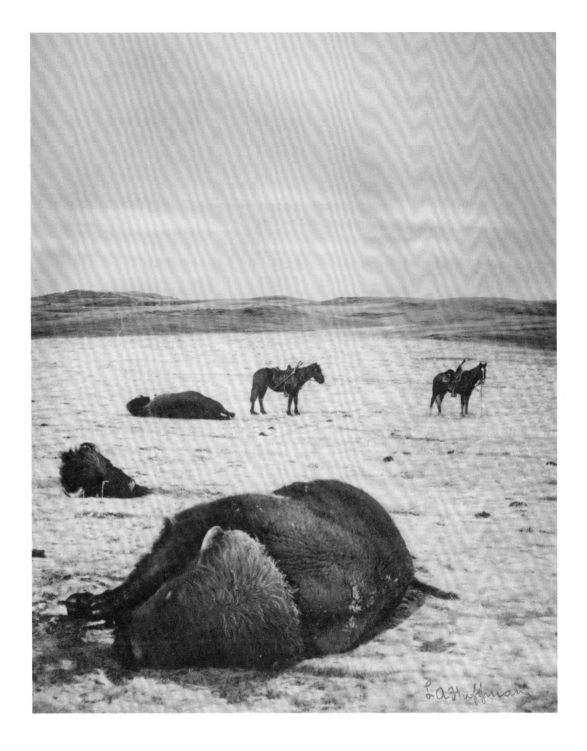

LATON ALTON HUFFMAN
After the Chase, North Montana Range, M.T. Jan 82., negative, January 1882; print, early 20th century

LOUIS FLECKENSTEIN
The Weary Messenger, ca. 1910

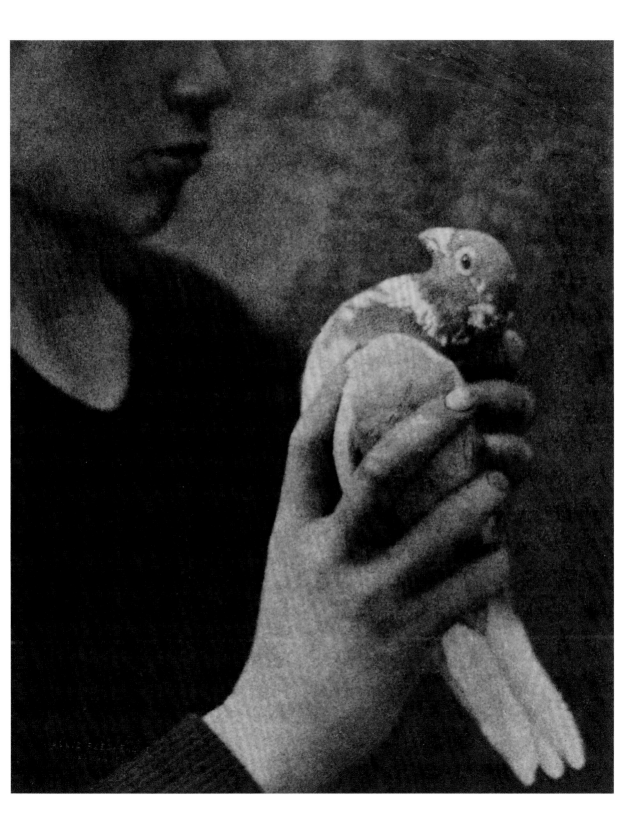

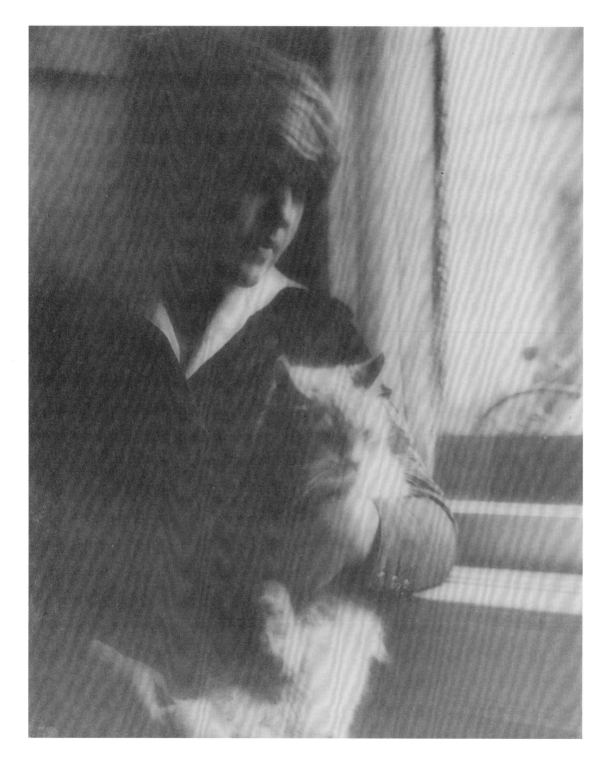

27 CLARENCE H. WHITE
Portrait of a Woman Posed with a Cat near a Window, 1918–20

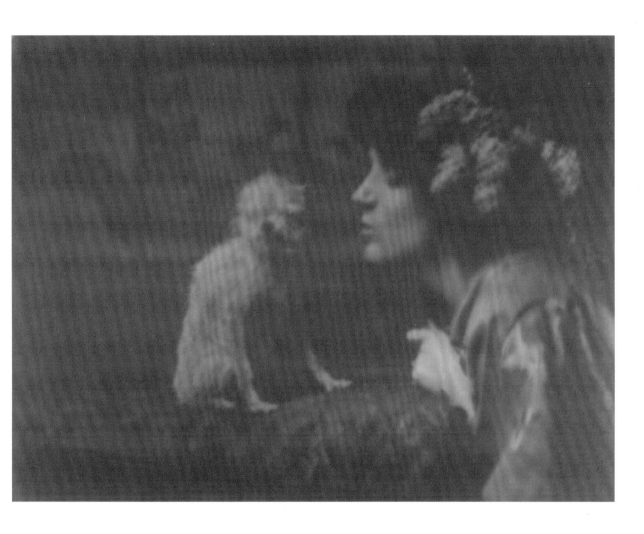

28 ARNOLD GENTHE
Mrs. Patrick Campbell, 1902

29 **ALFRED STIEGLITZ**
Spiritual America, negative, 1923; print, 1920s–30s

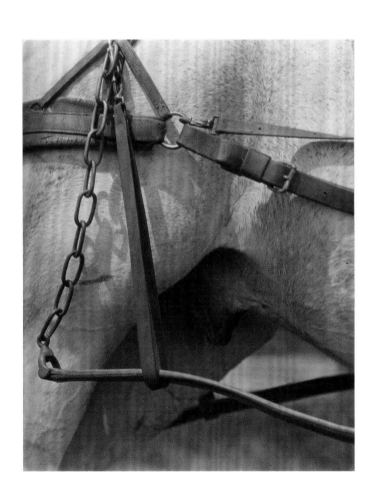

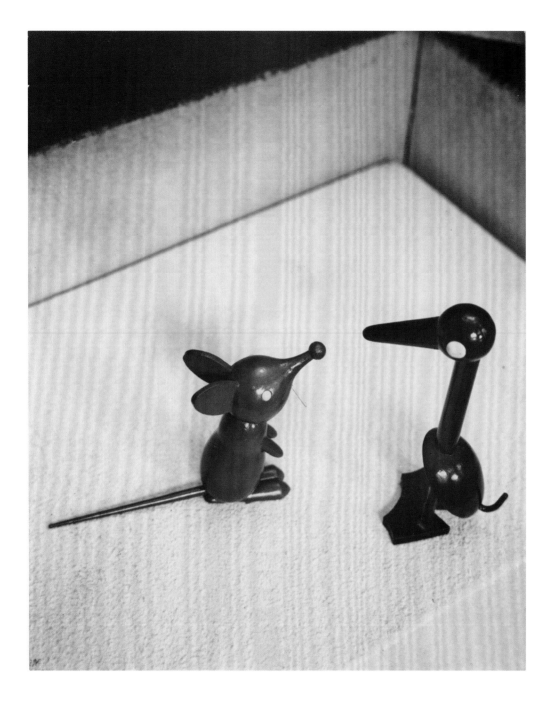

30 **ANDRÉ KERTÉSZ**
Wooden Mouse and Duck, 1929

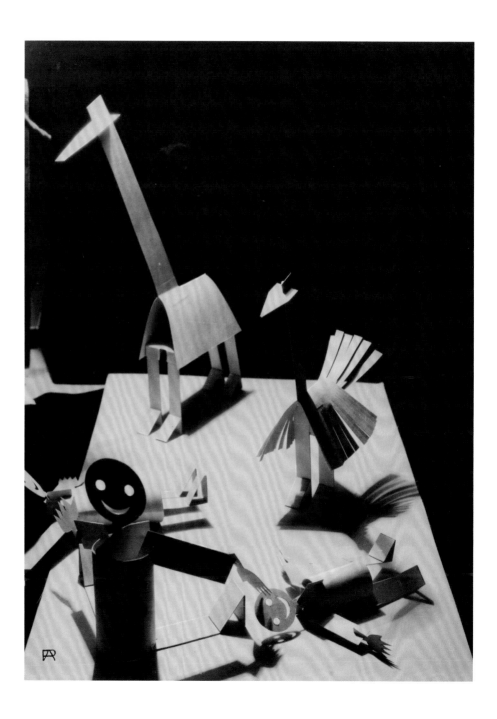

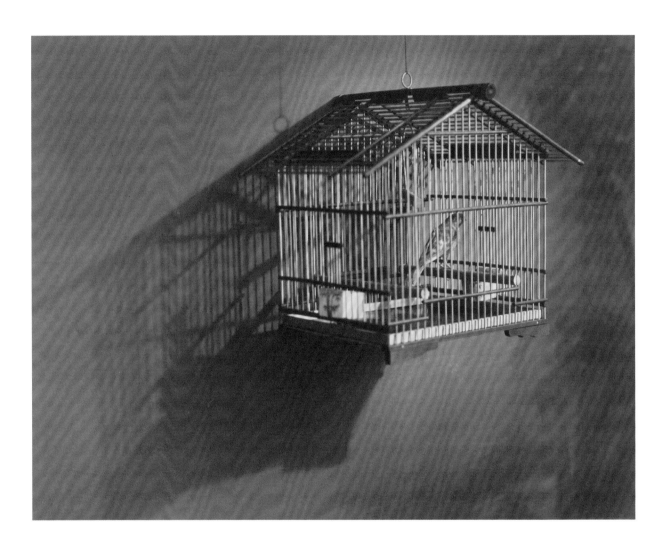

32 HIROMU KIRA
The Singer, ca. 1929

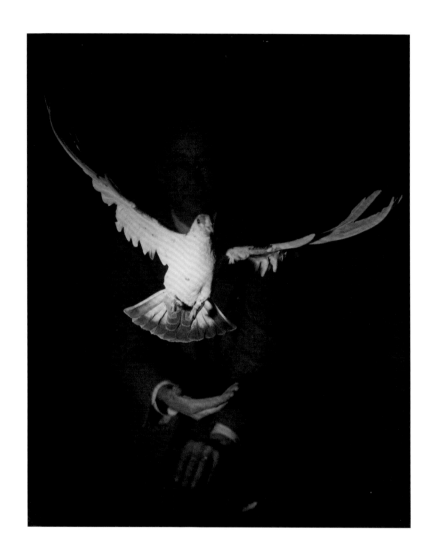

33 HAROLD EDGERTON
Dove Flying, Man Seated Behind, ca. 1930s

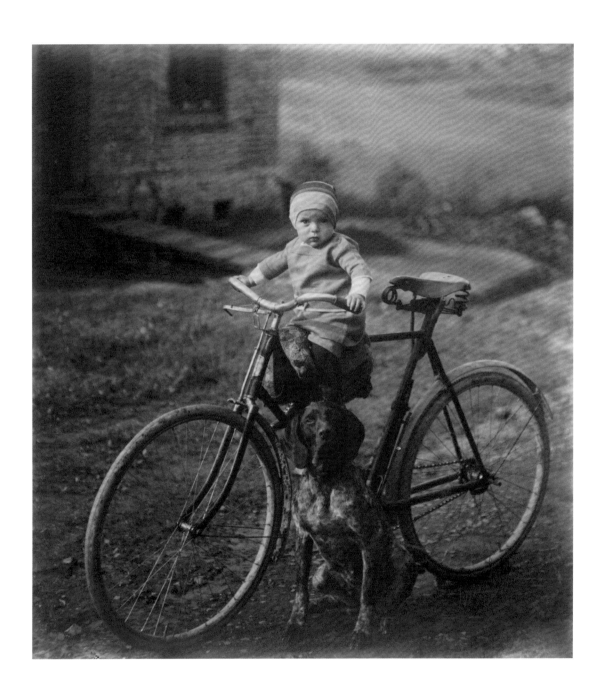

34　AUGUST SANDER
Untitled (Child, Westerwald), ca. 1926–27

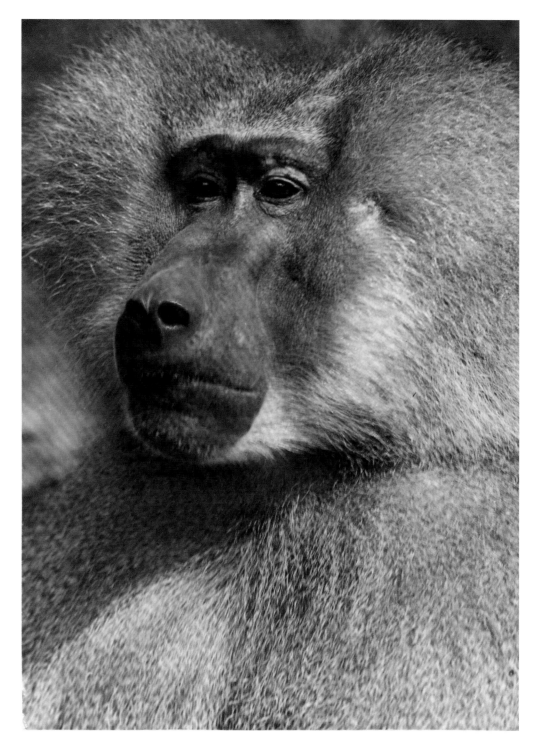

35 ALBERT RENGER-PATZSCH
Sacred Baboon (Mantelpavian), ca. 1928

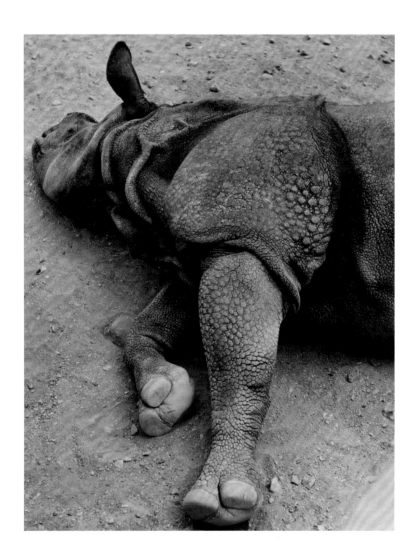

LISETTE MODEL
Rhinoceros Resting on Its Side, 1933–38

37 MANUEL ÁLVAREZ BRAVO
Ruin (B), 1930

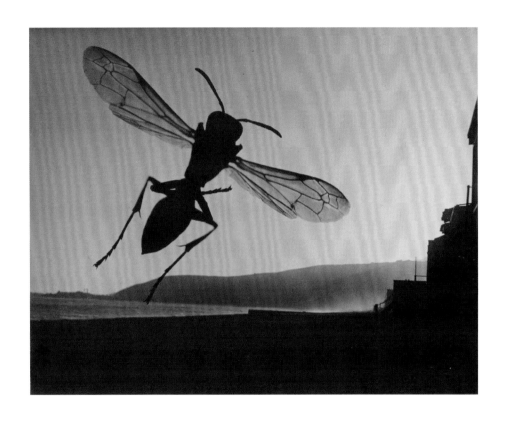

BERENICE ABBOTT
Lower East Side (Poultry Market, New York City), ca. 1936

MAN RAY
Fly, 1935–36

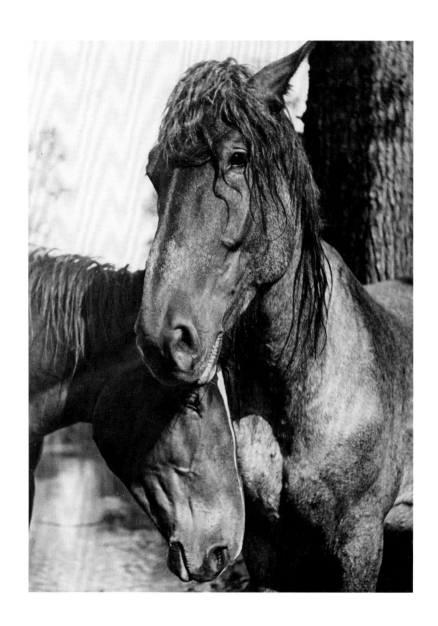

40 **YLLA**
Horses, 1930s

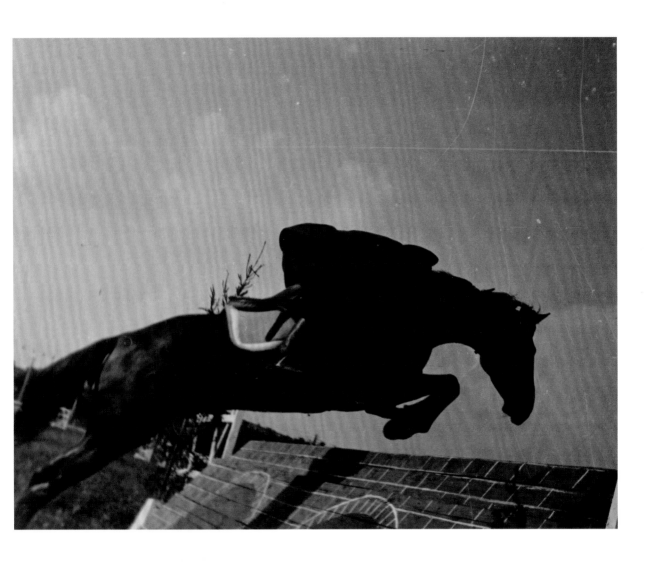

41 ALEXANDER RODCHENKO
Jump, 1934

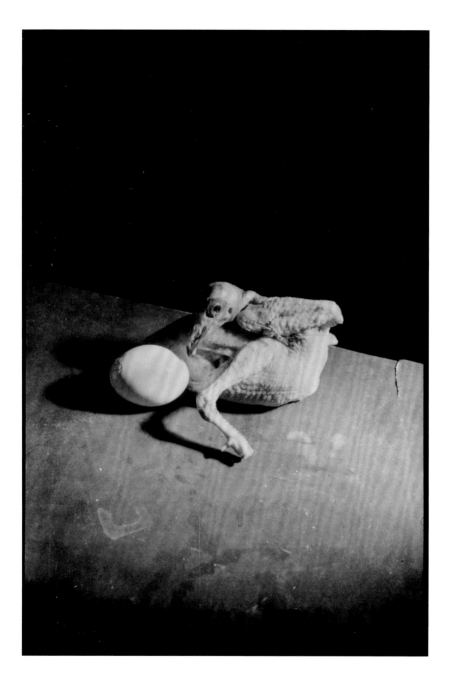

42 WOLS

Untitled (Chicken and Egg), negative, 1938–39; print, 1976

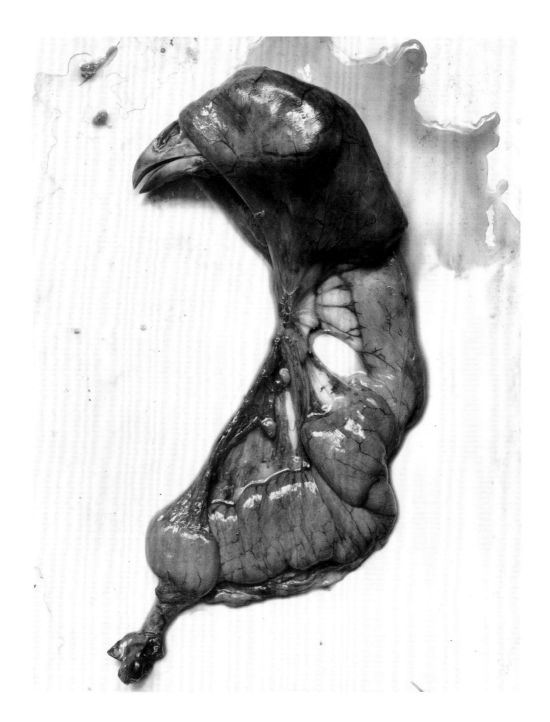

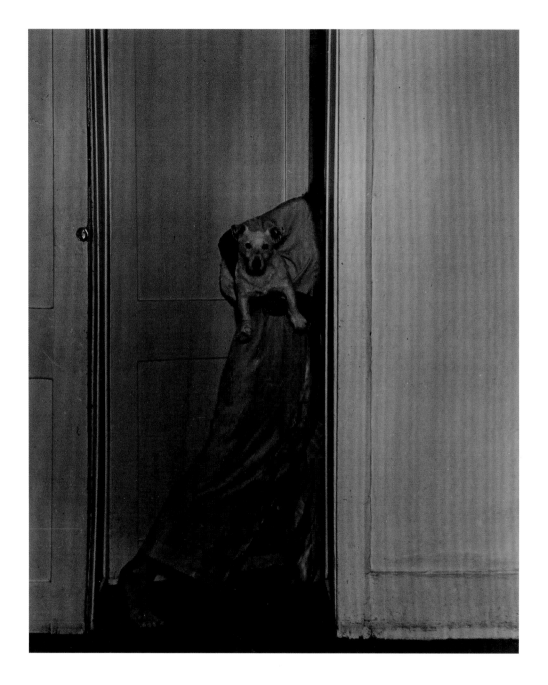

44 BILL BRANDT
Woman Exiting with Dog, ca. 1945

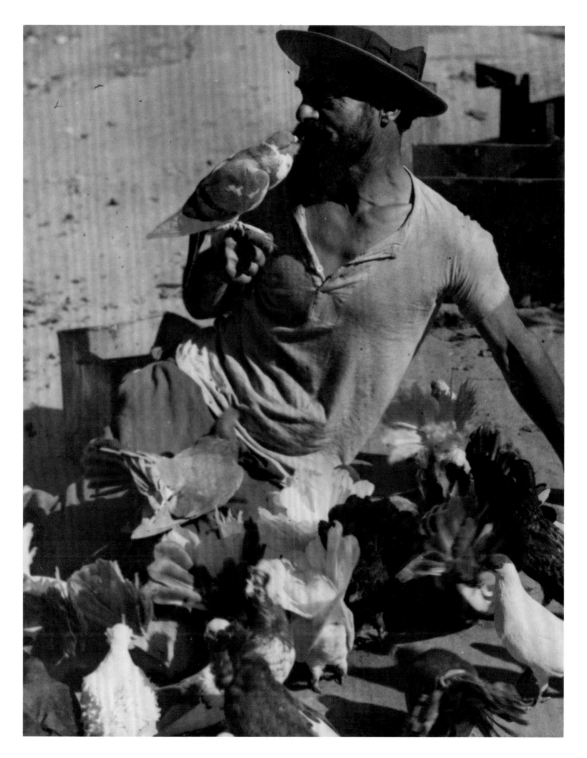

45 **MARTIN MUNKÁCSI**
The Pigeon-Breeder and His Favorite Bird, 1937

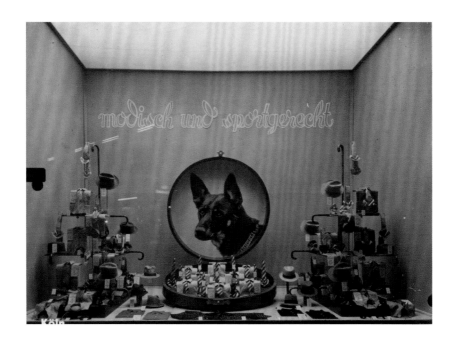

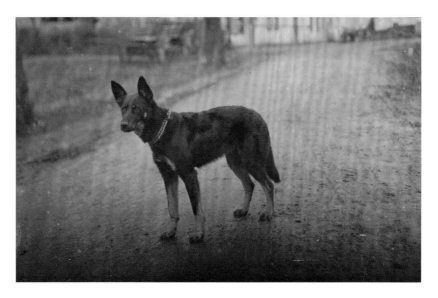

46 **ATTRIBUTED TO GUNTHER SANDER**
Storefront Window with August Sander Photograph of a Dog, ca. 1950

AUGUST SANDER
Dog, Westerwald, ca. 1925–30

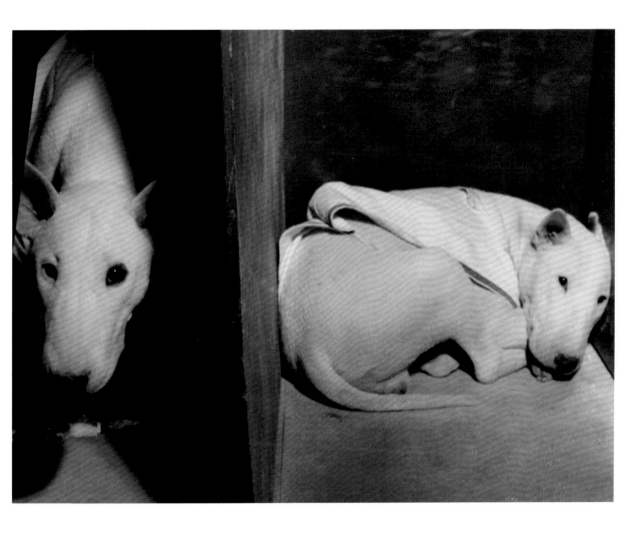

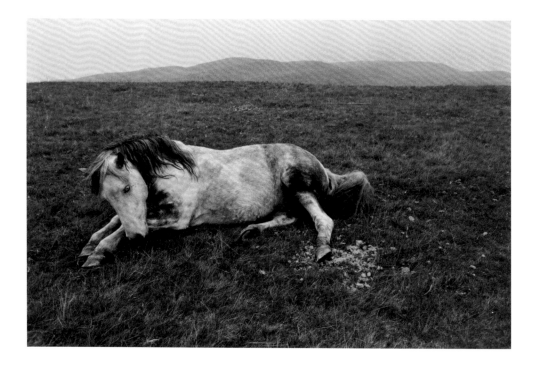

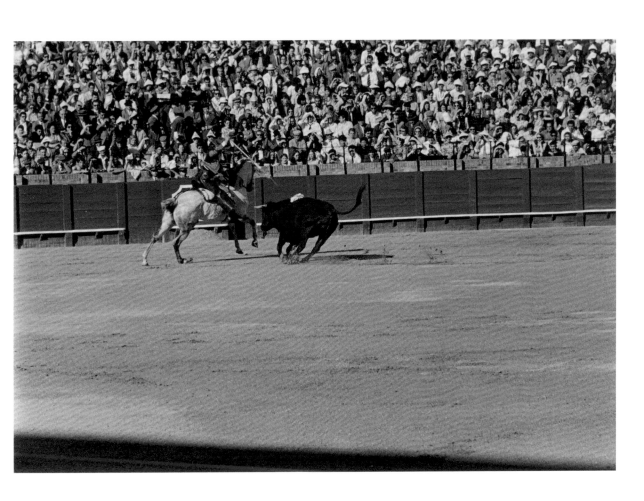

49 RALSTON CRAWFORD
Bull Fight, 1959

VAL TELBERG
Rebellion Group (Variations 2), ca. 1950

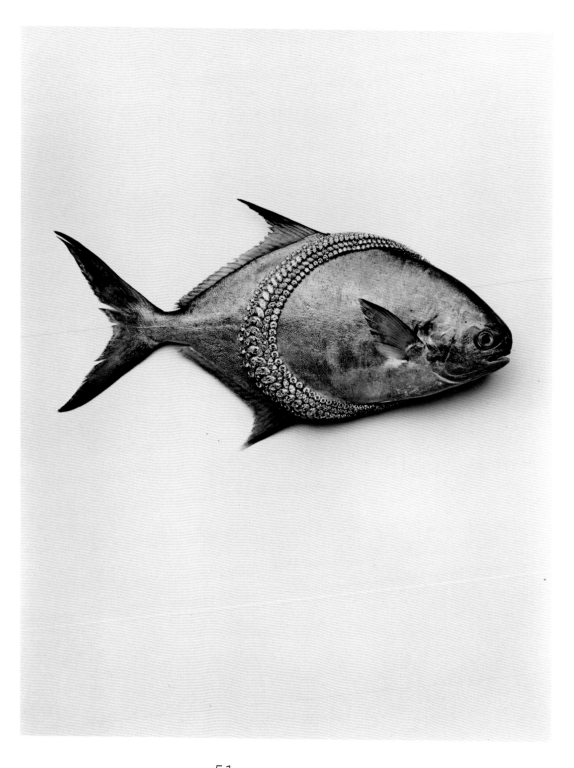

51 HIRO
Van Cleef & Arpels Necklace with Fish, New York, 1963

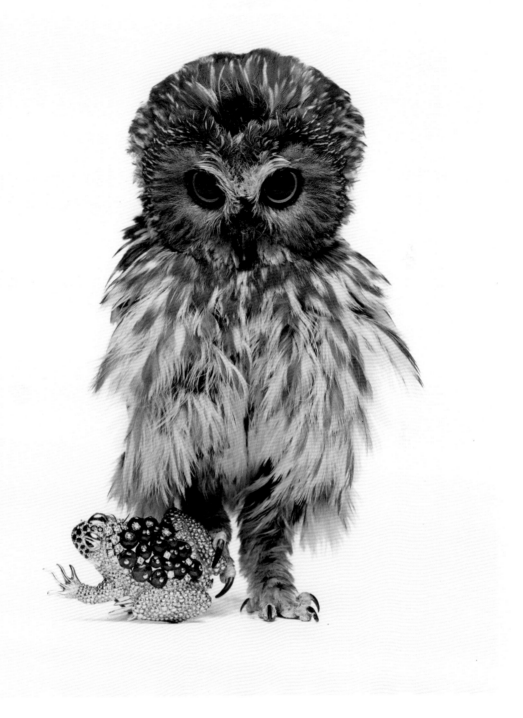

52　HIRO
David Webb, Jeweled Toad, New York, 1963

53 GARRY WINOGRAND
Central Park, New York City, negative, 1968; print, 1970

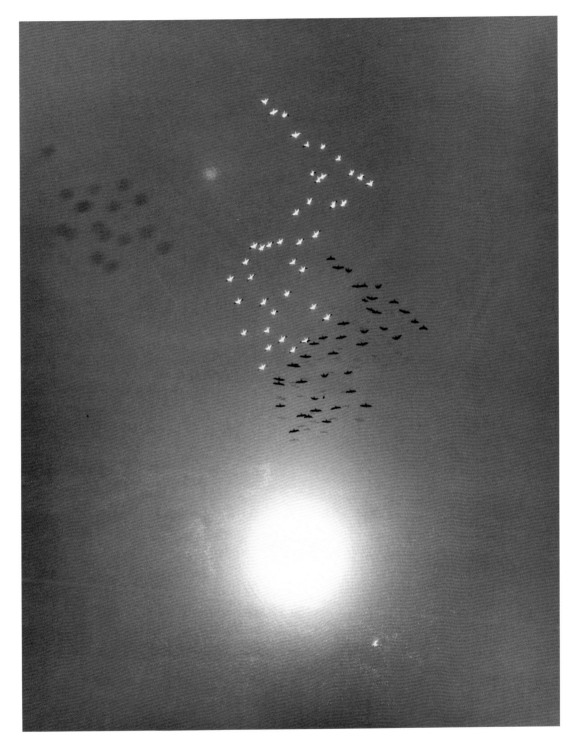

54 WILLIAM A. GARNETT
Snow Geese with Reflections of the Sun over Buena Vista Lake,
California, 1953

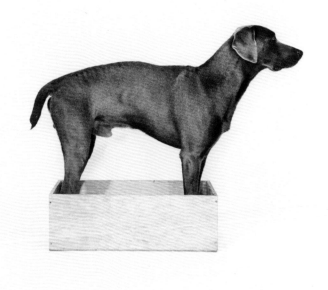

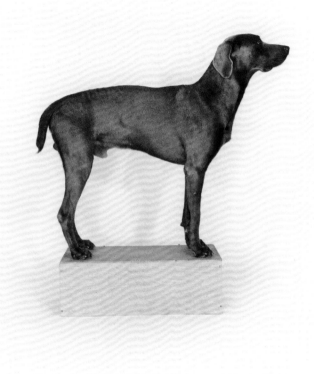

55 WILLIAM WEGMAN
In the Box / Out of the Box, 1971

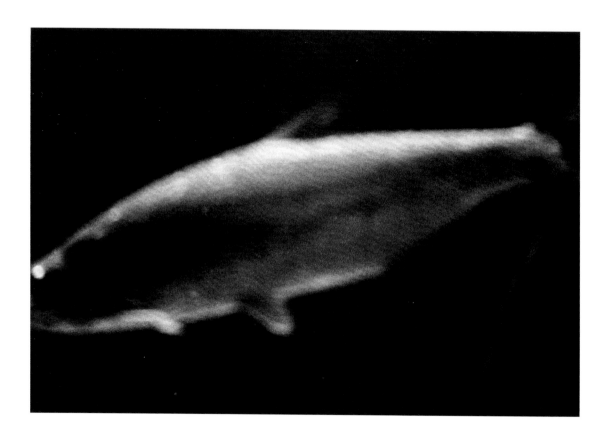

JUN SHIRAOKA
Coney Island, New York, February 1979

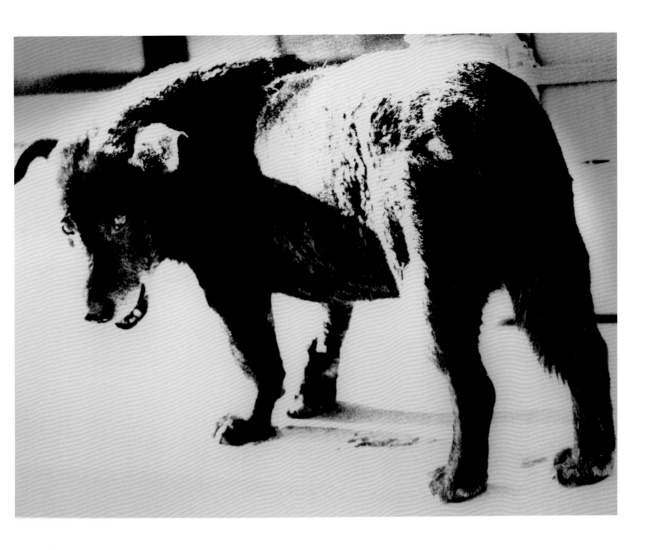

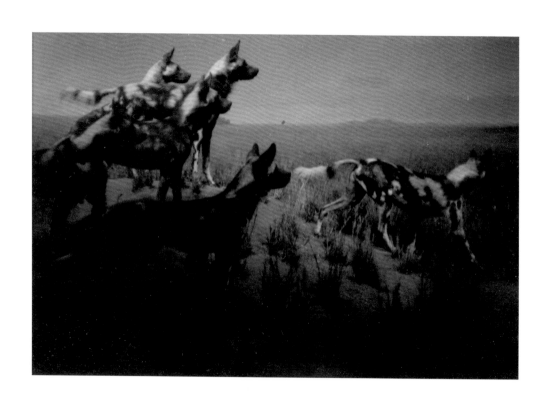

58 **ANITA CHERNEWSKI**
Wild African Dogs, 1976

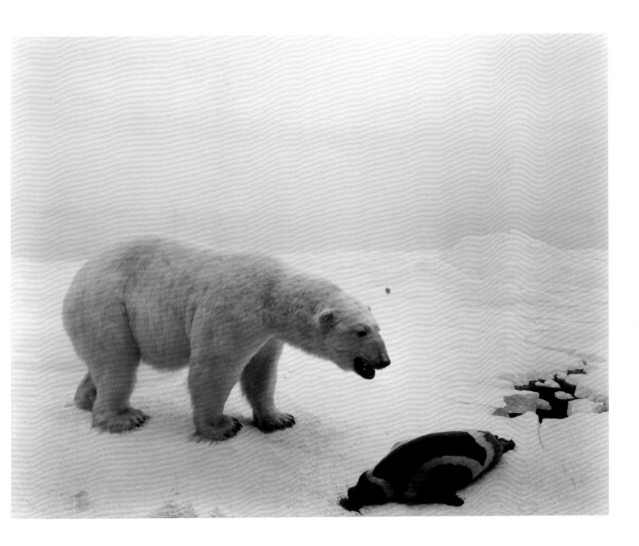

59 HIROSHI SUGIMOTO
Polar Bear, 1976

60 RICHARD BARON
Lassie, 1976

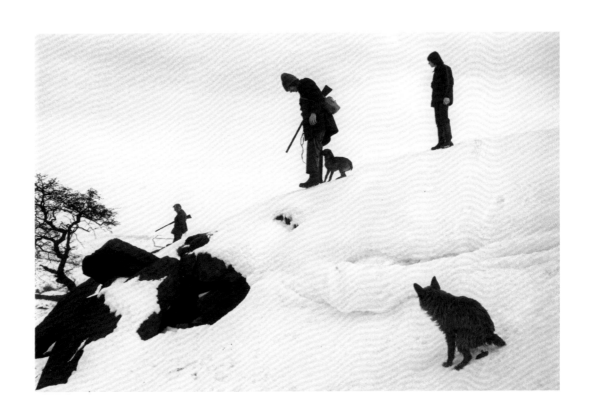

61 **MARTIN PARR**
Foxing, Crimsonworth, Hebden Bridge, 1977

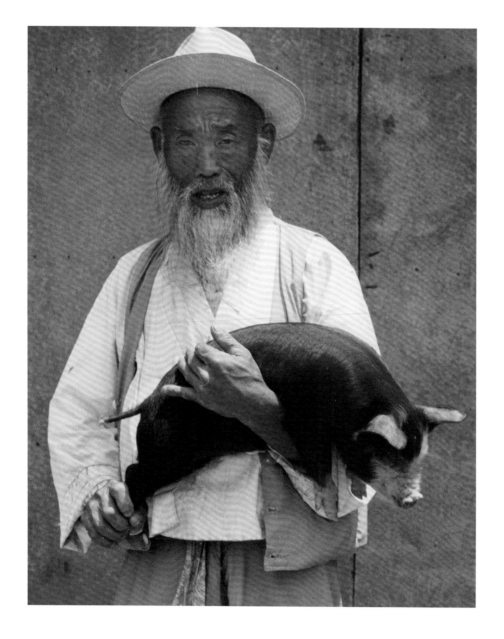

SOON TAE (TAI) HONG
Chong Ju, 1970

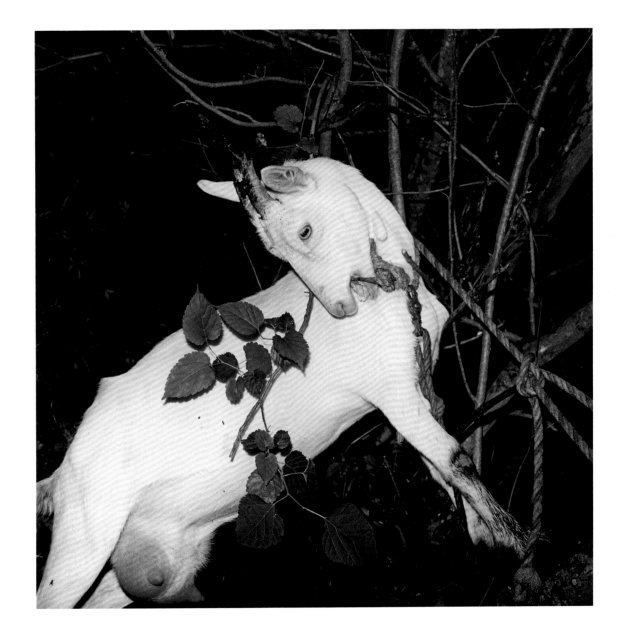

64 WILLIAM EGGLESTON
Memphis, negative 1971; print, 1974

65 SANDY SKOGLUND
Revenge of the Goldfish, 1981

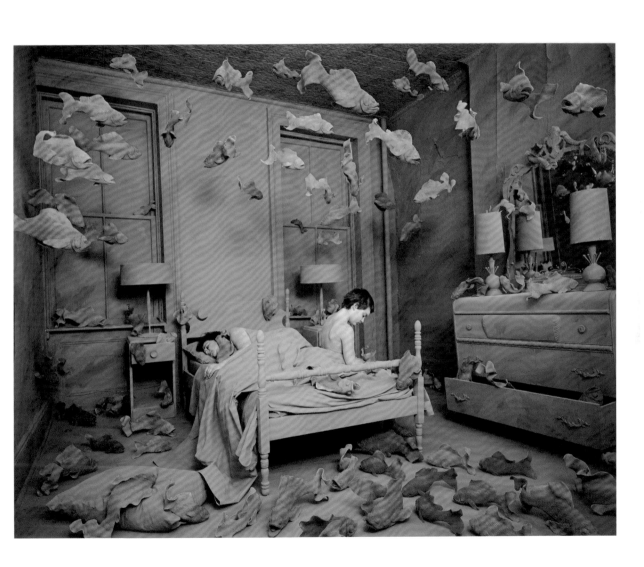

66 **ROBERT MAPPLETHORPE**
Kitten, Naples, 1983

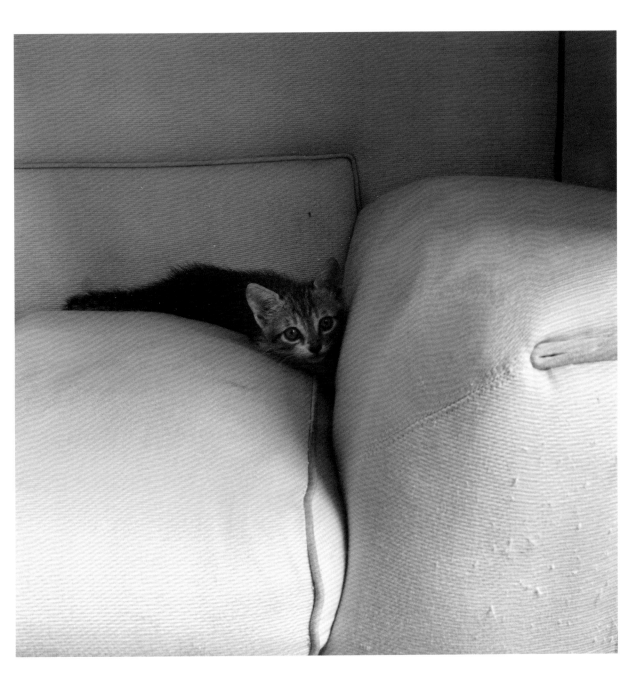

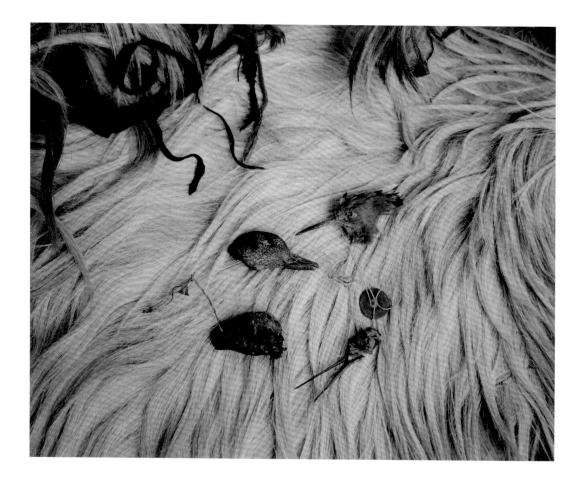

JANICA YODER
Untitled (Chicken Series), ca. 1980

69 ISSEI SUDA
Kikukawa, Sumida-ku, 1974

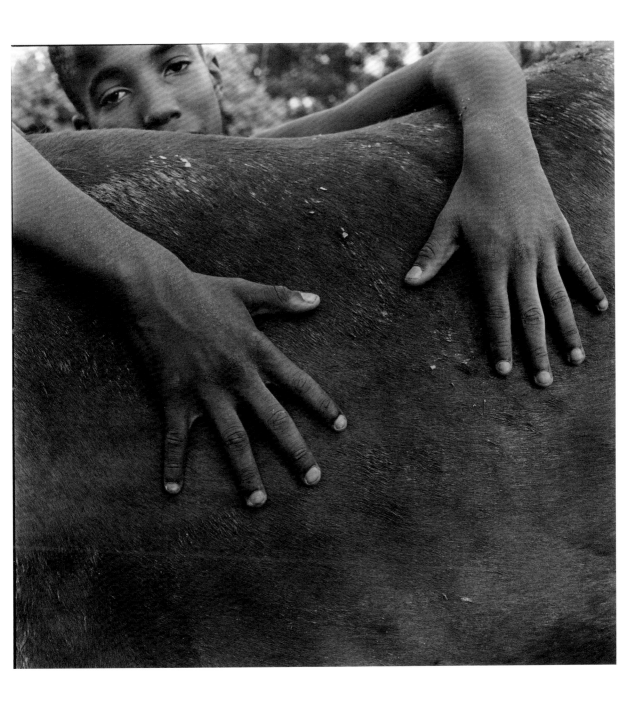

70 KEITH CARTER
Goodbye to a Horse, 1993

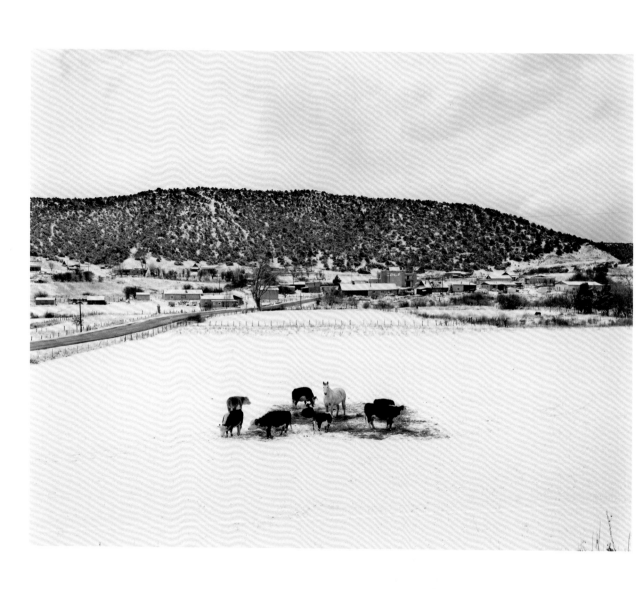

71 **ALEX HARRIS**
Las Trampas, New Mexico, negative, March 1984; print, 1993

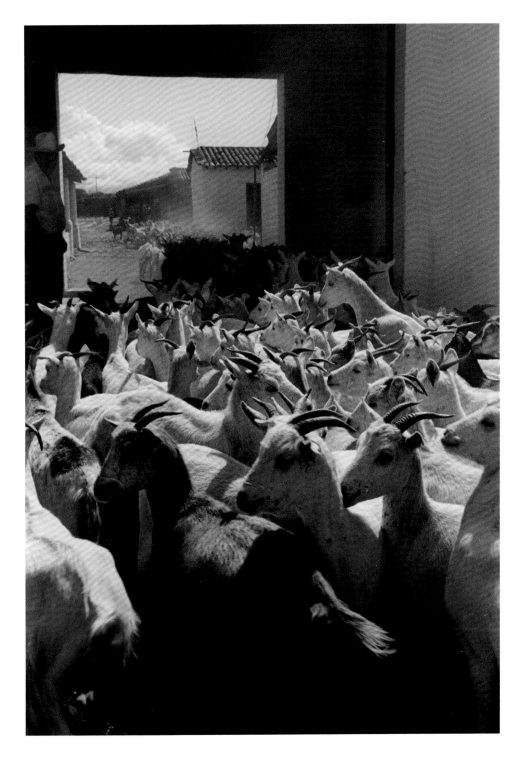

72 GRACIELA ITURBIDE
Cabritas, la Mixteca, México, 1992

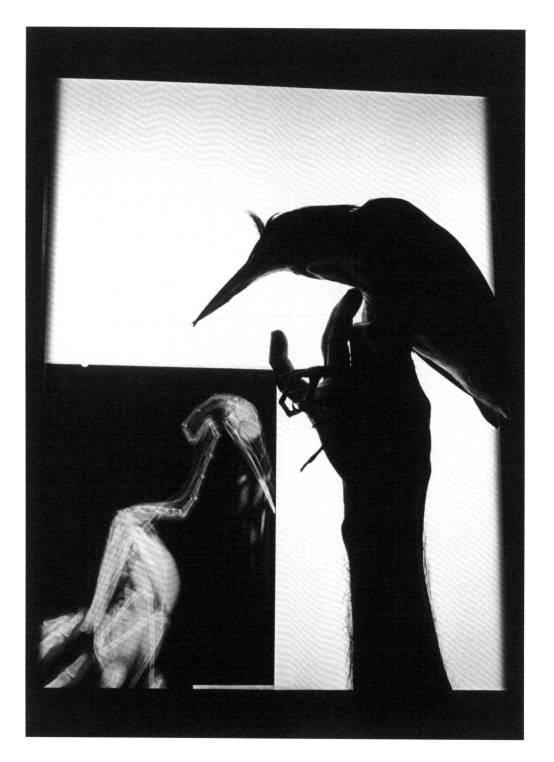

GRACIELA ITURBIDE
Radiografía de un pájaro con Francisco Toledo, Oaxaca, 1999

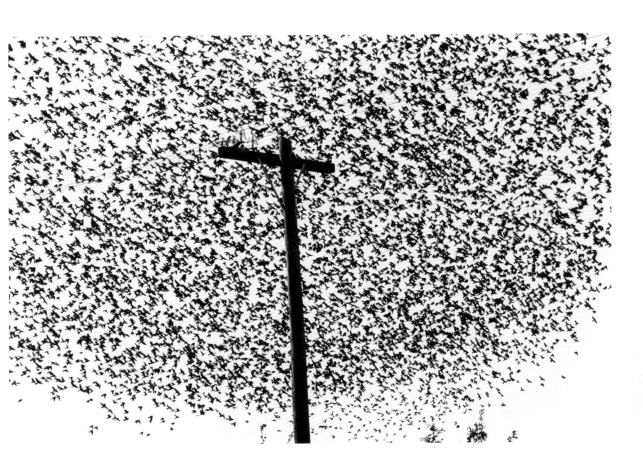

74 **GRACIELA ITURBIDE**
Pájaros en el poste, carretera a Guanajuato, México, negative, 1990;
print, 2000

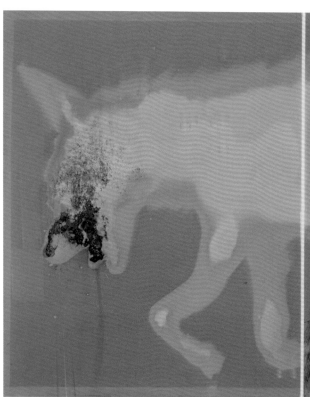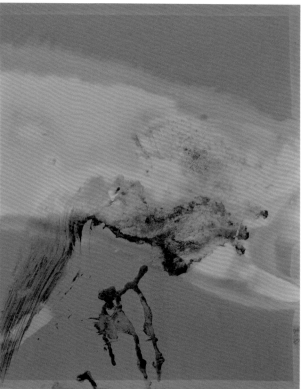

75 JERRY BURCHFIELD
Coyote Roadkill, 2002

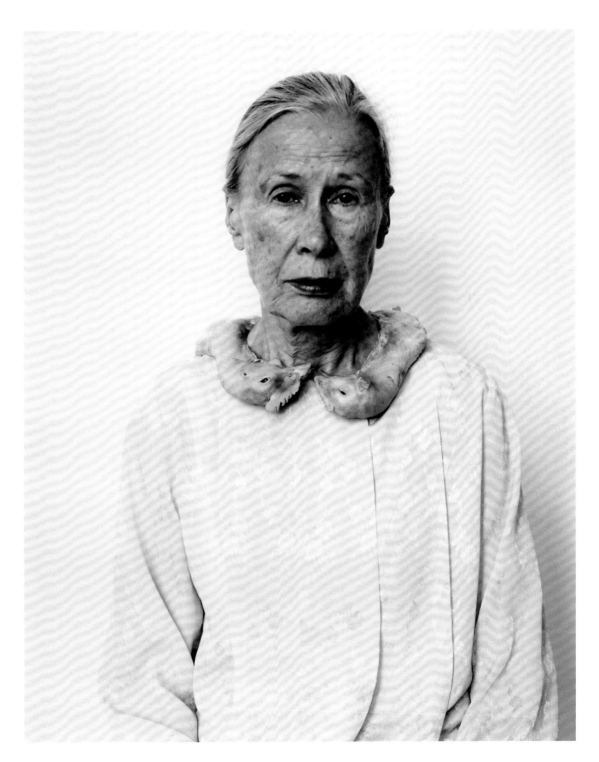

76 **PINAR YOLAÇAN**
Untitled, 2003

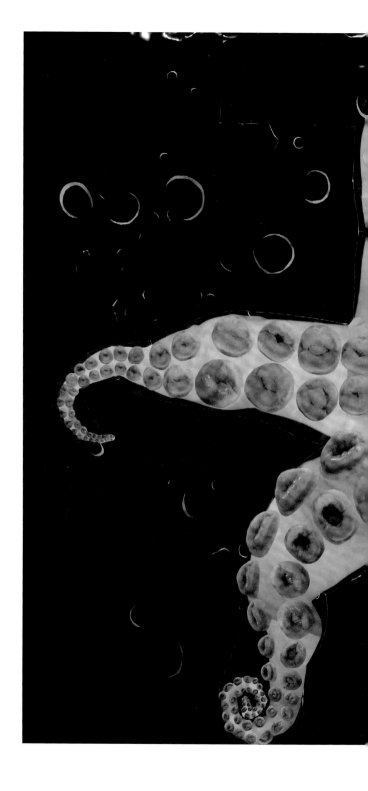

TIM HAWKINSON
Octopus, 2006

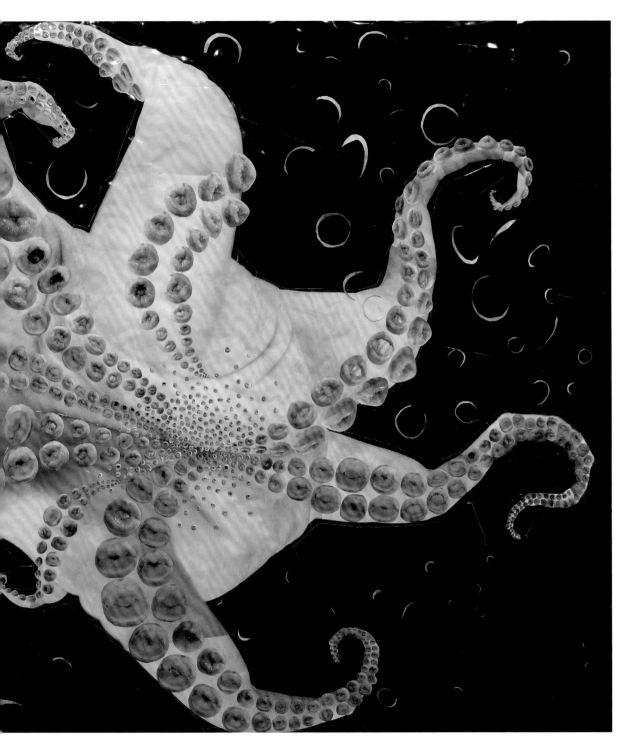

White Tiger (Kenny), Selective Inbreeding, Turpentine Creek Wildlife Refuge and Foundation,
Eureka Springs, Arkansas, negative, 2006; print, 2007

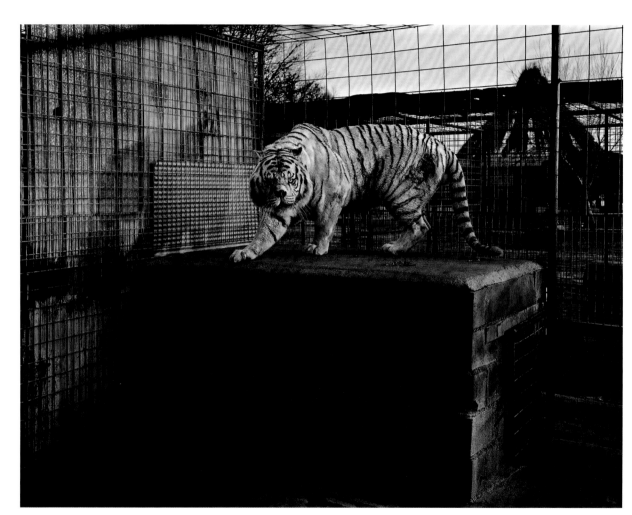

TARYN SIMON
White Tiger (Kenny), Selective Inbreeding, Turpentine Creek Wildlife Refuge and Foundation, Eureka Springs, Arkansas

In the United States, all living white tigers are the result of selective inbreeding to artificially create the genetic conditions that lead to white fur, ice-blue eyes and a pink nose. Kenny was born to a breeder in Bentonville, Arkansas on February 3, 1999. As a result of inbreeding, Kenny is mentally retarded and has significant physical limitations. Due to his deep-set nose, he has difficulty breathing and closing his jaw, his teeth are severely malformed and he limps from abnormal bone structure in his forearms. The three other tigers in Kenny's litter are not considered to be quality white tigers as they are yellow-coated, cross-eyed, and knock-kneed.

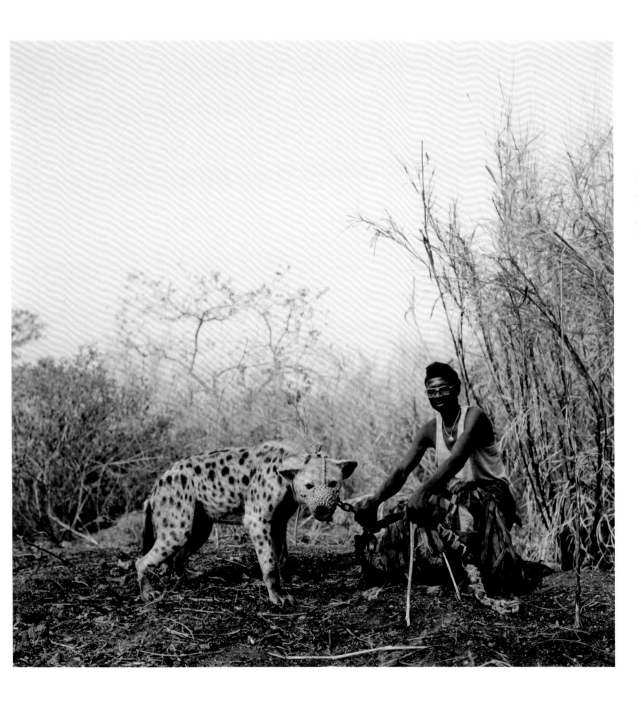

DANIEL NAUDÉ
Africanis 8. Barkly East, Eastern Cape, 5 July 2008, 2008

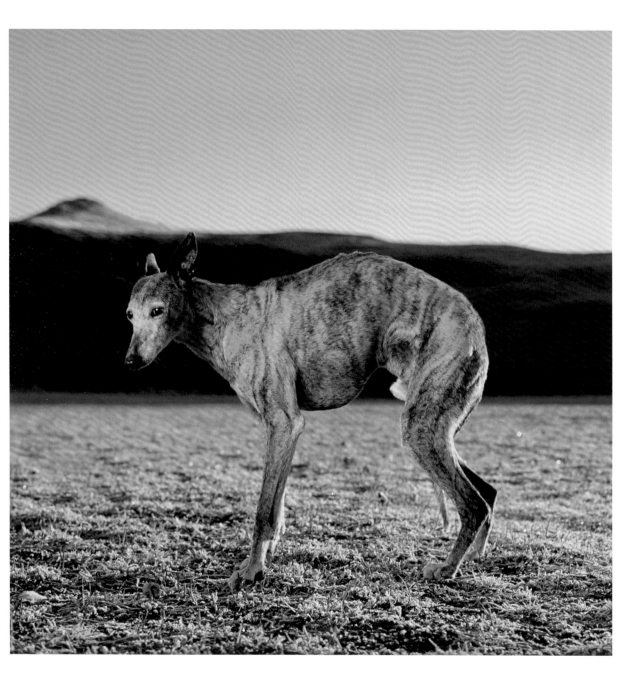

Plate List

All photographs are from the collection of the J. Paul Getty Museum, Los Angeles.

1
JEAN-GABRIEL EYNARD
Swiss, 1775–1863
Study of a White Foal, ca. 1845
Daguerreotype (½ plate)
8.3 × 11.3 cm (3¼ × 4 7⁄16 in.)
84.XT.255.37

2
JEAN-GABRIEL EYNARD
Swiss, 1775–1863
Carriage with Figures, 1849
Daguerreotype (½ plate)
11 × 14.6 cm (4 5⁄16 × 5¾ in.)
84.XT.255.9

3
UNKNOWN AMERICAN DAGUERREOTYPIST
Herdsman with Bull, ca. October 1852
From two daguerreotypes housed in
one case: (1) *Herdsman with Cow* and
(2) *Herdsman with Bull*
Daguerreotype (⅙ plate)
6.8 × 9 cm (2 11⁄16 × 3 9⁄16 in.)
84.XT.1582.15.2

4
JOHN BEVAN HAZARD
British, 1831–1892
Horses at a Trough, 1850s
Salted paper print
12.2 × 14.5 cm (4 13⁄16 × 5 11⁄16 in.)
84.XP.219.22

5
UNKNOWN AMERICAN DAGUERREOTYPIST
Outdoor Scene with Hunter and Dog,
ca. 1850
Daguerreotype (¼ plate)
9.4 × 7 cm (3 11⁄16 × 2¾ in.)
84.XT.1582.10

6
HORATIO ROSS
British, 1801–1886
Dead Stag in a Sling, 1850s–60s
Albumen silver print
27.9 × 33.2 cm (11 × 13 1⁄16 in.)
85.XM.169.2

7
UNKNOWN AMERICAN DAGUERREOTYPIST
Dog Sitting on a Table, ca. 1854
Hand-colored daguerreotype
(⅙ plate)
6.8 × 5.7 cm (2 11⁄16 × 2¼ in.)
84.XT.1582.16

8
UNKNOWN AMERICAN DAGUERREOTYPIST
*Portrait of a Seated Young Woman
and Dog*, 1845–47
Daguerreotype (½ plate)
10.3 × 8.9 cm (4 1⁄16 × 3½ in.)
84.XT.1575.6

9
ANTOINE CLAUDET
French, 1797–1867
Boy with Parrot, ca. 1856
Hand-colored daguerreotype
stereograph
Each: 6.7 × 5.7 cm (2⅝ × 2¼ in.)
84.XT.1566.11

10
HUGH WELCH DIAMOND
British, 1809–1886
Seated Woman with a Bird, ca. 1855
Albumen silver print
19.1 × 14.4 cm (7½ × 5 11⁄16 in.)
84.XP.927.3

11
ADRIEN ALBAN TOURNACHON
French, 1825–1903
Two Horses with Their Handlers,
1856
Diptych
Salted paper prints
Each: 16.1 × 14.3 cm (6⅜ × 5⅝ in.)
Mounted together
84.XM.1037.5; 84.XM.1037.6

12
JAMES VALENTINE
Scottish, 1815–1879
The Eagle's Nest, N.Z., ca. 1850–80
Gelatin silver print
18.5 × 29.1 cm (7 5⁄16 × 11 7⁄16 in.)
84.XP.447.28

13
ANDREW JOSEPH RUSSELL
American, 1830–1902
*Scene of Battle, Fredericksburg,
Virginia*, May 3, 1863
Albumen silver print
25 × 32.8 cm (9⅞ × 12⅞ in.)
84.XM.481.2

14
ADOLPHE BRAUN
French, 1811–1877
Still Life of Game, 1865
Carbon print
75.1 × 54 cm (29 9⁄16 × 21¼ in.)
84.XP.458.31

15
WILLIAM DESPARD HEMPHILL
Irish, 1816–1902
Still Life with Dead Animals,
1860s–70s
Albumen silver print
19 × 15.2 cm (7½ × 6 in.)
84.XP.673.12

16

THÉODULE DEVÉRIA
French, 1831–1871
Sleeping Dog, 1865
Albumen silver print
7.5 × 11.7 cm (2¹⁵⁄₁₆ × 4⅝ in.)
2009.85.7

17

LÉON CRÉMIÈRE
French, 1831–after 1882
Dogs, mid- to late 19th century
Albumen silver print
13.3 × 19.8 cm (5¼ × 7¹³⁄₁₆ in.)
84.XP.720.53

18

ERNEST LAWTON
British, act. 1860s–early 1880s
Heads and Tails, ca. 1866
Albumen silver print
20.8 × 27.2 cm (8³⁄₁₆ × 10¾ in.)
84.XP.703.20

19

FELICE BEATO
British, born Italy, 1832–1909
Fishmonger, 1866–67
From the album *Views of Japan*
Hand-colored albumen silver print
24.3 × 22.4 cm (9⁹⁄₁₆ × 8¹³⁄₁₆ in.)
84.XO.613.55

20

PASCAL SÉBAH
Turkish, 1823–1886
Hall of Camels, 1860s–70s
Albumen silver print
20.8 × 26.6 cm (8³⁄₁₆ × 10½ in.)
84.XM.1018.14

21

THOMAS JAMES DIXON
British, 1857–1943
Lion at Zoo, 1879
Albumen silver print
25.6 × 34.6 cm (10¹⁄₁₆ × 13⅝ in.)
84.XP.675.25

22

WILLIAM NOTMAN
Canadian, born Scotland, 1826–1891
Screech Owl, Mottled Owl. Red & Gray Stages, 1876
Albumen silver print
14 × 10.2 cm (5½ × 4 in.)
84.XB.1338.21

23

EADWEARD J. MUYBRIDGE
American, born England, 1830–1904
Animal Locomotion, 1887
Collotype
19.1 × 34.8 cm (7½ × 13¹¹⁄₁₆ in.)
84.XM.628.48

24

UNKNOWN PHOTOGRAPHER
Mother and Child, 1883
From the album *Nepaul*
Albumen silver print
16.5 × 26.7 cm (6½ × 10½ in.)
84.XA.1170.5

25

LATON ALTON HUFFMAN
American, 1854–1931
After the Chase, North Montana Range, M.T. Jan 82., negative, January 1882; print, early 20th century
Photogravure
25.4 × 20.3 cm (10 × 8 in.)
84.XM.506.11

26

LOUIS FLECKENSTEIN
American, 1866–1943
The Weary Messenger, ca. 1910
Toned gelatin silver print
23.9 × 19.8 cm (9⁷⁄₁₆ × 7¹³⁄₁₆ in.)
85.XM.28.49

27

CLARENCE H. WHITE
American, 1871–1925
Portrait of a Woman Posed with a Cat near a Window, 1918–20
Toned gelatin silver print
25.4 × 20.2 cm (10 × 7¹⁵⁄₁₆ in.)
84.XM.863.1

28

ARNOLD GENTHE
American, 1869–1942
Mrs. Patrick Campbell, 1902
Gelatin silver print
25.5 × 33.9 cm (10¹⁄₁₆ × 13⅜ in.)
84.XP.1005.2

29

ALFRED STIEGLITZ
American, 1864–1946
Spiritual America, negative, 1923; print, 1920s–30s
Gelatin silver print
11.5 × 9.1 cm (4½ × 3⁹⁄₁₆ in.)
93.XM.25.12

30

ANDRÉ KERTÉSZ
American, born Hungary, 1894–1985
Wooden Mouse and Duck, 1929
Gelatin silver print
20.9 × 16.7 cm (8¼ × 6⁹⁄₁₆ in.)
85.XM.131

31

ALEXANDER RODCHENKO
Russian, 1891–1956
Giraffe, 1926–27
Gelatin silver print
23.3 × 17 cm (9³⁄₁₆ × 6¹¹⁄₁₆ in.)
84.XM.844.7

32

HIROMU KIRA
American, 1898–1991
The Singer, ca. 1929
Gelatin silver print
26.4 × 34 cm (10⅜ × 13⅜ in.)
85.XP.29.68

33

HAROLD EDGERTON
American, 1903–1990
Dove Flying, Man Seated Behind, ca. 1930s
Gelatin silver print
25.4 × 20.3 cm (10 × 8 in.)
Gift of Gus and Arlette Kayafas
93.XM.3.6

34

AUGUST SANDER
German, 1876–1964
Untitled (Child, Westerwald), ca. 1926–27
Gelatin silver print
40.8 × 37.1 cm (16¹⁄₁₆ × 14⅝ in.)
85.XM.258.435

35

ALBERT RENGER-PATZSCH
German, 1897–1966
Sacred Baboon (Mantelpavian), ca. 1928
Gelatin silver print
37.7 × 27.5 cm (14¹³⁄₁₆ × 10¹³⁄₁₆ in.)
90.XM.101.10

36

LISETTE MODEL
American, born Austria, 1901–1983
Rhinoceros Resting on Its Side, 1933–38
Gelatin silver print
28.7 × 22.2 cm (11⁵⁄₁₆ × 8¾ in.)
84.XM.153.16

37

MANUEL ÁLVAREZ BRAVO
Mexican, 1902–2002
Ruin (B), 1930
Gelatin silver print
16.4 × 24.4 cm (6⁷⁄₁₆ × 9⅝ in.)
92.XM.23.2

38

BERENICE ABBOTT
American, 1898–1991
*Lower East Side (Poultry Market,
New York City)*, ca. 1936
Gelatin silver print
43.2 × 34.3 cm (17 × 13½ in.)
84.XM.1013.3

39

MAN RAY
American, 1890–1976
Fly, 1935–36
Gelatin silver print
19.4 × 24.8 cm (7⅝ × 9¾ in.)
84.XM.1000.131

40

YLLA
American, born Austria, 1911–1955
Horses, 1930s
Gelatin silver print
23.8 × 17 cm (9⅜ × 6¹¹⁄₁₆ in.)
84.XP.214.5

41

ALEXANDER RODCHENKO
Russian, 1891–1956
Jump, 1934
Gelatin silver print
24 × 30.3 cm (9⁷⁄₁₆ × 11¹⁵⁄₁₆ in.)
84.XM.258.49

42

WOLS
French, born Germany, 1913–1951
Untitled (Chicken and Egg), negative,
1938–39; print, 1976
Gelatin silver print
22.2 × 14.8 cm (8¾ × 5¹³⁄₁₆ in.)
84.XM.140.153

43

FREDERICK SOMMER
American, born Italy, 1905–1999
Chicken, 1939
Gelatin silver print
24.1 × 18.5 cm (9½ × 7⁵⁄₁₆ in.)
94.XM.37.98

44

BILL BRANDT
British, 1904–1983
Woman Exiting with Dog, ca. 1945
Gelatin silver print
23.1 × 18.6 cm (9⅛ × 7�5⁄₁₆ in.)
86.XM.618.3

45

MARTIN MUNKÁCSI
American, born Hungary, 1896–1963
*The Pigeon-Breeder and His Favorite
Bird*, 1937
Gelatin silver print
29.4 × 23.2 cm (11⁹⁄₁₆ × 9⅛ in.)
84.XP.780.4

46

ATTRIBUTED TO GUNTHER SANDER
German, 1907–1987
*Storefront Window with August Sander
Photograph of a Dog*, ca. 1950
AUGUST SANDER
German, 1876–1964
Dog, Westerwald, ca. 1925–30
Diptych
Gelatin silver prints
Each: 8.1 × 11.1 cm (3³⁄₁₆ × 4⅜ in.)
Mounted together
Studio of Gunther Sander
85.XM.258.445; 85.XM.258.446

47

LISETTE MODEL
American, born Austria, 1901–1983
Dog Show, ca. 1940–45
Gelatin silver print
25.9 × 33.8 cm (10³⁄₁₆ × 13⁵⁄₁₆ in.)
84.XM.153.6

48

BRUCE DAVIDSON
American, b. 1933
Wales, negative, 1965; print,
late 1970s
Gelatin silver print
28.8 × 43.6 cm (11⁵⁄₁₆ × 17³⁄₁₆ in.)
Gift of Nina and Leo Pircher
2013.54.7

49

RALSTON CRAWFORD
American, born Canada, 1906–1978
Bull Fight, 1959
Gelatin silver print
16.8 × 24.3 cm (6⅝ × 9⁹⁄₁₆ in.)
84.XM.151.83

50

VAL TELBERG
American, born Russia, 1910–1995
Rebellion Group (Variations 2),
ca. 1950
Gelatin silver print
23.3 × 28.1 cm (9³⁄₁₆ × 11¹⁄₁₆ in.)
84.XM.228.9

51

HIRO
American, born China, 1930
*Van Cleef & Arpels Necklace with
Fish, New York*, 1963
Dye imbibition print
50.5 × 39.1 cm (19⅞ × 15⅜ in.)
Purchased with funds provided by
the Photographs Council
2012.24.12

52

HIRO
American, born China, 1930
*David Webb, Jeweled Toad,
New York*, 1963
Dye imbibition print
50.2 × 39.1 cm (19¾ × 15⅜ in.)
Purchased with funds provided by
the Photographs Council
2012.24.13

53

GARRY WINOGRAND
American, 1928–1984
Central Park, New York City, negative,
1968; print, 1970
Gelatin silver print
34.1 × 23 cm (13⁷⁄₁₆ × 9¹⁄₁₆ in.)
99.XM.8.2

54

WILLIAM A. GARNETT
American, 1916–2006
*Snow Geese with Reflections of
the Sun over Buena Vista Lake,
California*, 1953
Gelatin silver print
34.6 × 26.8 cm (13⅝ × 10⁹⁄₁₆ in.)
84.XP.781.3

55

WILLIAM WEGMAN
American, b. 1943
In the Box / Out of the Box, 1971
Diptych
Gelatin silver print
Each: 35.5 × 27.7 cm (14 × 10⅞ in.)
2010.85.4.1; 2010.85.4.2

56

JUN SHIRAOKA
Japanese, b. 1944
Coney Island, New York,
February 1979
Gelatin silver print
32.5 × 48.1 cm (12¹³⁄₁₆ × 18¹⁵⁄₁₆ in.)
84.XP.716.2

57

DAIDO MORIYAMA
Japanese, b. 1938
Stray Dog, negative, 1971; print, later
Gelatin silver print
83.3 × 108.1 cm (32¹³⁄₁₆ × 42⁹⁄₁₆ in.)
Gift of James N. and Susan A.
Phillips
2011.74.1

58

ANITA CHERNEWSKI
American, b. 1946
Wild African Dogs, 1976
Gelatin silver print
8.9 × 13.3 cm (3½ × 5¼ in.)
84.XP.674.9

59

HIROSHI SUGIMOTO
Japanese, b. 1948
Polar Bear, 1976
Gelatin silver print
42.1 × 54.6 cm (16⁹⁄₁₆ × 21½ in.)
Purchased with funds provided by
the Photographs Council
2013.36.5

60

RICHARD BARON
American, b. 1947
Lassie, 1976
Gelatin silver print
32.4 × 24.8 cm (12¾ × 9¾ in.)
84.XP.716.23

61

MARTIN PARR
British, b. 1952
*Foxing, Crimsonworth, Hebden
Bridge,* 1977
Gelatin silver print
16 × 24.1 cm (6⁵⁄₁₆ × 9½ in.)
84.XP.446.13

62

SOON TAE (TAI) HONG
South Korean, b. 1934
Chong Ju, 1970
Gelatin silver print
24.8 × 20 cm (9¾ × 7⅞ in.)
2007.52.17

63

ISSEI SUDA
Japanese, b. 1940
Ginzan Onsen, Yamagata Prefecture,
1976
Gelatin silver print
22.5 × 22.3 cm (8⅞ × 8¾ in.)
Gift of Daniel Greenberg and
Susan Steinhauser
2012.100.2

64

WILLIAM EGGLESTON
American, b. 1939
Memphis, negative, 1971; print, 1974
Dye imbibition print
32.9 × 47.9 cm (12¹⁵⁄₁₆ × 18⅞ in.)
84.XP.674.15

65

SANDY SKOGLUND
American, b. 1946
Revenge of the Goldfish, 1981
Dye destruction print
70.7 × 89.2 cm (27¹³⁄₁₆ × 35⅛ in.)
Gift of John Torreano
94.XM.110

66

ROBERT MAPPLETHORPE
American, 1946–1989
Kitten, Naples, 1983
Gelatin silver print
38.5 × 38.5 cm (15³⁄₁₆ × 15³⁄₁₆ in.)
Promised Gift of The Robert
Mapplethorpe Foundation to
The J. Paul Getty Trust and
the Los Angeles County Museum
of Art
L.2012.89.125

67

LINDA CONNOR
American, b. 1944
Bird Heads, Ladakh, India, 1985
Gelatin silver print
20.4 × 25.1 cm (8¹⁄₁₆ × 9⅞ in.)
2005.15.47

68

JANICA YODER
American, b. 1950
Untitled (Chicken Series), ca. 1980
Gelatin silver print
37.3 × 46.6 cm (14¹¹⁄₁₆ × 18⅜ in.)
84.XP.786.30

69

ISSEI SUDA
Japanese, b. 1940
Kikukawa, Sumida-ku, 1974
Gelatin silver print
21.5 × 21.2 cm (8⁷⁄₁₆ × 8⅜ in.)
2008.51.3

70

KEITH CARTER
American, b. 1948
Goodbye to a Horse, 1993
Toned gelatin silver print
39 × 39.2 cm (15⅜ × 15⁷⁄₁₆ in.)
Gift of Daniel Greenberg and
Susan Steinhauser
2005.95.38

71

ALEX HARRIS
American, b. 1949
Las Trampas, New Mexico, negative,
March 1984; print, 1993
Chromogenic print
46.4 × 58.2 cm (18¼ × 22¹⁵⁄₁₆ in.)
Gift of Nancy and Bruce Berman
98.XM.214.10

72

GRACIELA ITURBIDE
Mexican, b. 1942
Cabritas, la Mixteca, México, 1992
Gelatin silver print
56.8 × 39.7 cm (22⅜ × 15⅝ in.)
Gift of Susan Steinhauser and
Daniel Greenberg
2007.65.2

73

GRACIELA ITURBIDE
Mexican, b. 1942
*Radiografía de un pájaro con
Francisco Toledo, Oaxaca,* 1999
Platinum print
52.1 × 36.8 cm (20½ × 14½ in.)
Gift of the artist and Rose Gallery
2007.24.5

74

GRACIELA ITURBIDE
Mexican, b. 1942
Pájaros en el poste, carretera a Guanajuato, México, negative, 1990; print, 2000
Platinum print
34.3 × 50.8 cm (13½ × 20 in.)
Gift of the artist and Rose Gallery
2007.24.4

75

JERRY BURCHFIELD
American, 1947–2009
Coyote Roadkill, 2002
Gelatin silver print
56.2 × 87.3 × 3.2 cm (22⅛ × 34⅜ × 1¼ in.)
Gift of Mary and Dan Solomon
2010.52.1

76

PINAR YOLAÇAN
Turkish, b. 1981
Untitled, 2003
From the series Perishables
Chromogenic print
101.2 × 82.2 cm (39¹³⁄₁₆ × 32⅜ in.)
Gift of Dale and Doug Anderson
2009.101.1

77

TIM HAWKINSON
American, b. 1960
Octopus, 2006
Inkjet digital foam collage
240 × 355.6 × 6.4 cm (94½ × 140 × 2½ in.)
Commissioned by the J. Paul Getty Museum
2007.35

78

TARYN SIMON
American, b. 1975
White Tiger (Kenny), Selective Inbreeding, Turpentine Creek Wildlife Refuge and Foundation, Eureka Springs, Arkansas, negative, 2006; print, 2007
From the series An American Index of the Hidden and Unfamiliar
Chromogenic print
64.5 × 83.5 cm (25⅜ × 32⅞ in.)
2009.26.1

79

PIETER HUGO
South African, b. 1976
Mallam Galadima Ahmadu with Jamis, Nigeria, negative, 2005; print, 2010
From the series The Hyena and Other Men
Chromogenic print
100 × 100 cm (39⅜ × 39⅜ in.)
Purchased with funds provided by the Photographs Council
2010.25.1

80

DANIEL NAUDÉ
South African, b. 1984
Africanis 8. Barkly East, Eastern Cape, 5 July 2008, 2008
Chromogenic print
73.7 × 73.7 cm (29 × 29 in.)
2014.26.3

This book is published on the occasion of the exhibition *In Focus: Animalia*, on view at the J. Paul Getty Museum at the Getty Center, Los Angeles, from May 26 to October 18, 2015.

Published by the J. Paul Getty Museum, Los Angeles

Getty Publications
1200 Getty Center Drive, Suite 500
Los Angeles, California 90049-1682
www.getty.edu/publications

Dinah Berland, *Project Editor*
Jane Friedman, *Manuscript Editor*
Catherine Lorenz, *Designer*
Stacy Miyagawa, *Production*

Printed in Hong Kong

Library of Congress Cataloging-in-Publication Data

Kovacs, Arpad, 1984– author.
 Animals in photographs / Arpad Kovacs.
 pages cm
 "This book is published on the occasion of the exhibition In Focus: Animals, on view at the J. Paul Getty Museum at the Getty Center, Los Angeles, from May 26 to October 18, 2015."—ECIP galley.
 ISBN 978-1-60606-441-2 (hardcover) — ISBN 1-60606-441-X (hardcover)
1. Photography of animals—Exhibitions. 2. Animals in art—Exhibitions. 3. Photography, Artistic—Exhibitions. 4. Photography—History—Exhibitions. 5. J. Paul Getty Museum—Exhibitions. I. J. Paul Getty Museum, issuing body. II. Title. III. Title: In focus, animals.
 TR727.K68 2015
 779'.32—dc23

 2014032558

FRONT JACKET: Daniel Naudé, *Africanis 17. Danielskuil, Northern Cape, 25 February 2010*, 2010 (detail, fig. 12)
BACK JACKET: Jean-Gabriel Eynard, *Study of a White Foal*, ca. 1845 (plate 1)
PAGE 1: Harold Edgerton *Dove Flying, Man Seated Behind*, ca. 1930s (detail, plate 33)
PAGE 2: William Eggleston, *Memphis*, negative, 1971; print, 1974 (detail, plate 64)
PAGE 3: Alex Harris, *Las Trampas, New Mexico*, negative, March 1984; print, 1993 (detail, plate 71)
PAGES 4–5: Jun Shiraoka, *Coney Island, New York*, February 1979 (detail, plate 56)

Illustration Credits